D0870298

THE TRUE NORTH
CANADIAN LANDSCAPE PAINTING 1896 - 1939

EDITED AND WITH AN INTRODUCTION
BY MICHAEL TOOBY

WITHDRAWN
FROM LAKEHEAD UNIVERSITY
LIBRARY

LUND HUMPHRIES, LONDON
IN ASSOCIATION WITH

BARBICAN ART GALLERY

ND
1352
C2T78
1991
c. 1

222987

The arts are vital to a healthy society and the business community has an essential role to play in their promotion.

As Britain's leading quality daily newspaper, The Daily Telegraph is substantially increasing its commitment to arts sponsorship in 1991, demonstrating the importance that the newspaper gives to the arts through editorial coverage.

As part of this commitment to the arts, The Daily Telegraph is proud to be sponsoring this exhibition.

The Daily Telegraph

Bringing Canada to the World

At Air Canada, we believe that a world in which people understand each other, is a better world. And the insight that Canada's artists offer can lead to a better understanding of our nation.

Nothing communicates more directly, or intensely, than art. The artist is able to bring to the surface images which truly reflect a country's nature and dimension. The force of these images can provide the viewer with a deeper insight.

That is why Air Canada is proud to sponsor *The True North: Canadian Landscape Painting 1896-1939*. We believe it offers a unique opportunity to experience Canada from a new perspective.

A BREATH OF FRESH AIR

Air Canada

CONTENTS

INTRODUCTION

The True North forms one of a series of exhibitions that Barbican Art Gallery has programmed to date, that have reconsidered various international art movements of the late nineteenth and early twentieth century. Canadian art, from the beginning of this century, showed many links with British artists and it is fitting that this relationship should be now illustrated in a major display at Barbican Art Gallery, especially since there has been no significant large-scale display of this early twentieth-century work since the Tate Gallery Exhibition in 1938.

Much ground has been covered in the research of this period in recent years and we hope that this exhibition will play a further part in revising views of this important body of work. We are particularly grateful to Michael Tooby for proposing and selecting this exhibition, as well as co-ordinating the contributions from the eminent Canadian writers featured in this publication. It is fitting, too, that we are presenting this exhibition in combination with another major Canadian exhibition called *Un-Natural Traces*, which focuses on recent developments in the art of Canada and describes the manner in which the earlier fascination for the observation of natural phenomena has become an investigation of the unnatural or hidden elements of contemporary Canadian existence.

We are also indebted to the group of public institutions in Canada that have enabled us to bring the exhibition to Britain. It is a measure of the Canadian support for this project that virtually all loan requests have been facilitated. Barbican Art Gallery has thus been able to present a display the importance of which, in terms of Canadian art, would make such an assembly of works under one roof a major event even in Canada itself, let alone 3000 miles away, and we would like to thank the many lenders in Canada for their generosity and co-operation.

Nearly all major public institutions in Canada and some private lenders, as well as the Musée des Beaux Arts in Lyon and the Tate Gallery in London, have generously helped us to make this exhibition possible. We would like to thank the authors who are contributing to this book but also the individuals without whose patience and co-operation the practical task of co-ordinating this exhibition would have been impossible – Catherine Laing at the National Gallery of Canada, Catherine L. Spence of the Art Gallery of Ontario, Sandy Cook of the McMichael Canadian Art Collection and Nathalie Vanier of the Musée des Beaux-Arts in Montréal.

To bring an exhibition of this size and complexity to London also requires considerable financial support and we are very grateful to our two sponsors, Air Canada and *The Daily Telegraph*, for making it possible. Furthermore, their strong commitment to the wider appreciation of art was a great encouragement in the planning stages.

In this we should like to thank Lilian Rayson and Jane Whigham of Air Canada; and Jo Henwood and Michele Marcus of *The Daily Telegraph*; and Belle Shenkman for their personal involvement.

The Culture and Sports Division of the Department of External Affairs, Government of Canada, has supported this presentation of Canadian art in London from the outset and we are grateful for their generous financial assistance. We would also like to acknowledge the assistance of the Canada Council for the Arts.

In Britain, The Canadian High Commission has given us every support and advised us in each stage of the exhibition's progress. We would like to thank René Picard, Cultural Counsellor, and his predecessor, Curtis Barlow, for their close interest and support as well as Michael Regan, Visual Arts Officer, for his enthusiasm and encouragement throughout its organization. We are also grateful to Visiting Arts for their assistance towards the symposium, *Defining Canada*, which will highlight some of the most crucial issues raised by this and *The Un-Natural Traces* exhibition.

Finally we would once again like to thank the Canadian lenders for their support and enthusiasm, and we very much hope the exhibition will convey the pleasure that we, together with Michael Tooby, have had in organizing it.

John Hoole, Curator
Brigitte Lardinois, Exhibition Organiser

ACKNOWLEDGEMENTS

My work on this exhibition was made possible by my being released by Sheffield City Council, in parallel to my work on the exhibition *Our Home and Native Land: Sheffield's Canadian Artists*. I am grateful for this opportunity, and to my colleagues in Sheffield Arts Department who created the time for me to research the exhibition in Canada, particularly David Alston, Anne Goodchild, and all the staff of the Mappin Art Gallery.

My one regret about the coincidence of the 'Sheffield' exhibition with the present one is that the two central figures in my research, Arthur Lismer and Frederick Varley, are under-represented here. This is, obviously, not a reflection of my view of their art, which is at the heart of my interest in Canadian art. It is also a source of regret that, due to its refurbishment coinciding with the exhibition, the Musée du Québec were unable to lend works to represent some of the best artists of that province.

Many individuals across Canada have shown me encouragement and advice throughout my work on the exhibition and this publication, often benevolently indulging my outsider's view.

Dennis Reid has provided the quality of advice in all the different aspects of the project that is a product both of his immense knowledge of the field and his generosity and openness. Charles Hill and Robert Stacey have indulged the trials brought on by my learning

process with astounding patience. I am also extremely pleased that Maria Tippett and Esther Trépanier responded to my request to write for this publication given their extremely busy schedules and the limitations of space and time necessitated by working to an exhibition timetable.

I am grateful to all the lenders who made available some of their most precious possessions. At the lending galleries, Alf Bagusky, Roger Boulet, Megan Byce, Nicole Cloutier, Sandra Cooke, Judy Dietz, Gary Essar, Dorothy Farr, Susan Foshay, Ross Fox, Elizabeth Kidd, Cathy Mastin, Michael Parke Taylor, Bernard Riordan, Catherine Spence, Judi Schwartz, and Ian Thom all gave me kind assistance.

The National Gallery of Canada has not only lent some outstanding works, but provided me with a variety of practical support. In particular Maija Vilcjins and her colleagues in the library, with Elaine Phillips in the Gallery's archives, helped me obtain a variety of material; Katherine Laing and her colleagues in the registration area collated and arranged much of the loan material; and I am particularly grateful to Rosemary M. Tovell, Associate Curator of Canadian Prints and Drawings, who selected the group of prints by David Milne to relate to my selection.

I am grateful to John Kirby at the Sheffield Polytechnic Library, Ann House at the Library of Canada House, London, and the staff of the Library at the Art

Gallery of Ontario for assistance in the research for the exhibition.

Throughout my numerous visits to Canada I have received much practical help and warm hospitality. I am particularly grateful to Margaret Keith, Chris Varley, Michael and Nancy Parke Taylor, Suzanne Funnel, Jack Butler, Sheila Butler, Peter Varley, Elizabeth Mackenzie, and many others.

The staff at Canada House Cultural Centre, London, have provided friendly support, and I am most grateful to Michael Regan, Curtis Barlow and their colleagues, and must also thank their predecessors Griselda Bear and David Peacock who first provided me with guidance on visiting Canada. I am grateful to Jane Whigham and Air Canada for providing assistance toward my travel to and within Canada during my research.

John Hoole and his colleagues at the Barbican Art Gallery, especially Brigitte Lardinois, Carol Brown, Donna Loveday, Christine Stewart, Anna Parker and Judy Digney have made the exhibition a pleasure to work on.

I am delighted that this project is accompanied by an exhibition in which Bruce Ferguson has played a leading role, since a conversation with him at the 1982 Venice Biennale was, if such things can be dated, the point at which I became seriously interested in the study of Canadian art.

Jane, Sarah and Matthew Tooby have given the time and space for me to work, and they now have the chance to begin to share what took me away for such long periods: whether to another country or another room.

Michael Tooby, Sheffield, January 1991

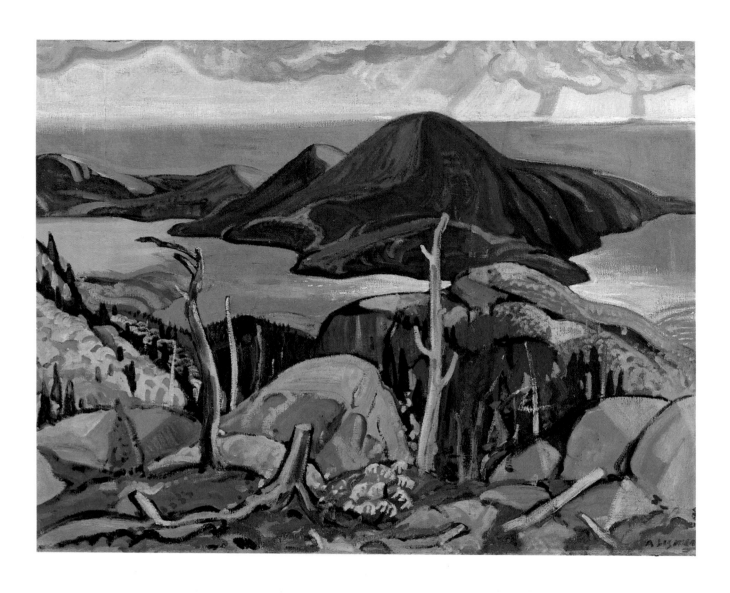

Arthur Lismer, *Sombre Isle of Pic,* 1927
Collection Winnipeg Art Gallery (cat. 63)

ORIENTING THE TRUE NORTH

Oh, Canada! Our home and native land!

True patriot love in all thy sons' command.

With glowing hearts we see thee rise

The true north strong and free.[1]

Exhibitions with themes, even those defined by national boundaries, are often said to be arbitrary or speculative: a reflection of the interests of the overseeing eye, or a contingency created to facilitate presentation. What will strike anyone with a passing knowledge of Canadian art about the selection for this exhibition is its obviousness. Indeed, the major source of speculation for a Canadian might be upon how so many sacred icons have been permitted to leave their halls.

The British audience might assume that landscape painting is an appropriate vehicle for the study of Canadian art because of the inevitable images of the country thrust upon us in advertising and popular literature. In these Canada is the great outdoors, a wilderness of mountains, lakes and forests perfect for strenuous exploration and sublime contemplation.

Instead, the landscape painting from the first part of the twentieth century featured in our exhibition is both obvious and fundamental in discussing Canadian art since it has itself acted as an ideological and psychological vehicle for defining Canada. In a country where today almost 80 per cent of the population lives in urban areas, this early modern art dominates both popular consciousness of what constitutes Canadian art, and forms a central body of material for intellectual, academic and artistic debate over the development of a sense of national identity in the visual arts and in Canadian culture as a whole.[2]

A visitor to the country might find it surprising just how well known some of the twentieth-century Canadian artists are. The ubiquity of images by Tom Thomson, the Group of Seven and Emily Carr, their daunting familiarity to most Canadians, creates particular problems and issues for anyone approaching the subject. There are, however, important questions of how we in this country, as interested viewers not immersed in the social, political, historical and anecdotal knowledge which surrounds these works in Canada can respond.[3]

The background knowledge which informs this body of work differs from historical debate about the retrieval of past contexts. The background knowledge in this instance is current and general in the present. There is also the possibility of feeling that Canada represents one point along a cultural continuum, and that distance from a critical and metropolitan

Cover of Penguin Travel Guide
to Canada, 1985-1986

Leaflet of the McMichael Canadian
Art Collection

centre represents distance in interest, raising notions of whether an art further from the 'centre', wherever that may be taken to be, has diffused to a place and time at a remove, the distance travelled in space and time being suitable for measurement and discussion.[4]

The reverse is true. The conditions for creating the centrality of this body of work in Canada were intimately bound up with the structures and economic and political conditions created by the United Kingdom in the last quarter of the nineteenth century, in the crucial period immediately following Canada's confederation, but most interesting is the debate in Canada about what form this response should take.

The focus of this exhibition, with its companion project focusing on contemporary Canadian art, is highly specific. It is not our project, for example, to make any statement vis-à-vis native Canadian art, of whatever community, nor to compare this Canadian art with any other body of work, including British art.

The exhibition represents roughly three 'generations' of artists: generations in the sense of phases of artistic production rather than age or chronological relationship. First comes the earliest consciously modernist painting of the Canadian landscape, by artists from Montreal in the 1890s and 1900s; and a contrasting group of artists who made landscape work from their base in Toronto over the same period. Then there is the mature work of Tom Thomson and the Group of Seven, which is set in the exhibition with a group of works by Emily Carr, who was closely associated with the Group and who is here represented by a selective range of pieces from the 1930s, and David Milne, an artist who returned to his native Canada in 1928 and worked in some isolation. Last is the work of artists who in a different sense might be considered as 'followers', though not necessarily in a qualitative sense, from Quebec painters of the 1920s and 1930s, to

MICHAEL TOOBY

those who formed some of the early members of the Canadian Group of Painters, founded as the successor body to the Group of Seven in 1934.

In this publication, the present essay is accompanied by four Canadian writers. Each takes a different approach, from different conceptual, geographic and stylistic viewpoints: Robert Stacey discusses the emergence of the dominant artists in Toronto, while Charles Hill explains and discusses the crucial and controversial role played by the National Gallery of Canada in supporting the new landscape art and so creating a 'national' school. Standing apart from this, Esther Trépanier presents some views of how the Group of Seven were perceived in the 'alternative' culture of Quebec, while Maria Tippett suggests how we might consider an individual response to what elsewhere is described as a highly politicized and strategic question, of how to depict the true north, the real Canada.

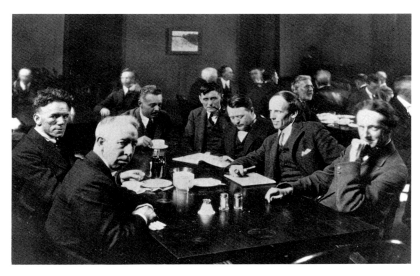

The Group of Seven at the Arts and Letters Club, 1920
Left to right: Varley, Jackson, Harris, Barker Fairley (a writer who supported the group),
Johnston, Lismer and MacDonald; Carmichael was not in the photograph

It is a mark of how much work there is to do in this country on our relationships with foreign cultures, even those as intimately bound up with ours as Canada,[5] that we can say here that we hope the exhibition will lead to precisely that: further debate, enquiry and recognition. In order to facilitate this, the aim of the publication is to set out some initial information and some key ideas which are specific to the body of work in question.

While the epithet 'new' should not be applied to Canada as a country, there is an important sense that, within the colonial period, the point at which our exhibition begins can be described as a new start, and this idea is taken up by some of the exhibition's protagonists.[6]

The country defined as a whole as Canada was only thirty years old. After confederation in 1867 there were a series of political initiatives to build a fresh sense of national commitment. This was in response to Canada's new political status.[7] The 1880s saw Canada's first real urban growth and industrialization, with the installation of electricity and the telegraph. The last spike of the Canadian Pacific Railway was hammered in 1885, and the first train from the East rolled into

Charles W. (C.W.) Jefferys, *A Prairie Sunset,* 1915
Collection Art Gallery of Ontario, Toronto (cat. 60)

the new town of Vancouver in May 1886. A vast physical space which created an artificial east-west chain of connection, when 'natural' geographic connections existed in a series of north-south regions isolated across Canada from one another. This east-west chain was arraigned along the border with the United States which was emerging at the turn of the century as the most powerful economy in the world, overtaking in influence the other formative force in Canada's history, the British Empire.[8]

This exhibition takes its title from the Canadian national anthem. 'Oh Canada' was a song of old French 'Canadien' life. It became sung as an expression of French Canadian nationalism, first listed in 1836. The first published words were by the Quebec judge Adolphe-Basile Routhier to a tune by Calixa Lavallée in 1880.[9] Routhier's words are nostalgic in their militaristic defensiveness:

O Canada, terre de nos aïeux
Ton front est ceint de fleurons glorieux
Car ton bras sait porter l'épée…

Et ta valeur, de foi trempée
Protégera nos foyers et nos droits

David Milne, *Palgrave,* 1931
Collection Art Gallery of Ontario, Toronto (cat. 80)

While the English version, by Robert Stanley Weir, published in 1906, is thrusting, vigorous:

O Canada! Our home and native land!

True patriot love in all thy sons' command.

With glowing hearts we see thee rise

The true north strong and free; O Canada,

We stand on guard for thee.

The anthem doubled up with 'God Save the Queen' on state and national occasions (i.e. there were three options!) until 1968, when the two Canadian versions were formally adopted. The anglophone anthem brings out the masculine, physical qualities that were perceived to be the keys to success in the Dominion, but the contingent way it could be employed

shows how ambiguous any one definition of national qualities in the country might be.

At the turn of the century, with 'Canada' one generation old, its consolidation as a political unit saw the height of immigration from Europe, and the growth of Toronto as a second urban centre to rival Montreal, the traditional centre of trade and communications on the St Lawrence. The 1890s saw the burgeoning of a new nationalism which required a common culture, made sharper by the need to establish a common tongue across the colonial communities.[10]

For English speakers, this new nationalism could be framed within the Imperialist feelings of mutual interdependence between the parent country and its new children, in the familial metaphor so frequently employed which cast Canada as 'John Bull's Big Daughter'.[11] Immigration from Britain was consequent on a number of factors: the massive population explosion in the nineteenth century, the subsidies available from government and commerce, and the new markets sought by British capital seeking to expand once the British infrastructure looked like levelling off. It meant that English culture could flourish, while French culture, marginalized, began to be regressive, nostalgic for an imagined purer French past.

In common with other outward manifestations of nationalism across Europe and the Empire in the second part of the nineteenth century, Canada began to express itself in national culture. The political powers shared with leading citizens and significant sectors of the immigrant communities a sense of the value and importance of establishing institutions for cultural support. These were inevitably dominated by the English-speaking institutions established by the Dominion.

An added ingredient in the development of a cultural sense of identity was the urbanization of the different Canadian communities. The zones of occupation in the vast new country were very rapidly defined and filled. These became urban and surburban communities who depended on the economic transactions of the massive natural resources of the rest of the country: wood, grain, fish and later coal and minerals. Between 1901 and 1921 the population grew from 5.3 million to 8.8 million, in 1921 40 per cent of the population living in Ontario and Quebec.[12]

The forming of separate urban centres meant that any sense of nationhood resided in whichever centre became predominant.[13] Thus any nationalist project becomes, ironically, highly divisive. While an urban centre such as Toronto, reinforced by English-speaking politicians in other centres and of course in the capital Ottawa, might cultivate a vision of the surrounding landscape as the national identity, reaction from another centre is bound to emerge.

However, Carl Berger, in discussing the image of Canada as 'the true north, strong and free' has suggested that, because of the legacy of political and cultural structures and sentiment established by imperialism, much nationalism will be inevitably expressed in a fascination with the north, the remote landscape that Canada's population centres are surrounded by.[14] In Northrop Frye's memorable image, this immense stretch of land exerts the same pressure on the Canadian populace as a large piece of cake on a small child: 'an unknown but quite possibly horrible Something stares at them in the dark: hide under the bedclothes as long as they like, sooner or later they must stare back'.[15]

The work of Tom Thomson and the Group of Seven is generally cited as central to the process of accommodating the consciousness of the intimidating presence of the lonely north; that their painting of the Canadian north country was the first true Canadian art, placing the consciousness of the north within the national consciousness of Canada as 'the true north'. The problem revolves around whether the idea of something 'Canadian' resides in the nature of the painting concerned or in institutional definitions.

There had been attempts to establish organizations to promote the fine arts in Canada since the 1830s. The first to distinguish itself as 'Canadian' was the Society of Canadian Artists, which had a short life immediately following

James E.H. (J.E.H.) MacDonald, *March Evening, Northland,* 1914
National Gallery of Canada, Ottawa (cat. 66)

confederation. Characteristically, the two organizations to establish a role for themselves were formed by artists based in Canada's two main cities. The Art Association of Montreal was established in 1860, and the Ontario Society of Artists, based in Toronto, in 1872. Equally characteristically, as debate developed over the best way to foster a genuinely national strategy for promoting arts, and as artists' organizations developed in other centres across the country, the leading politicians had to reconcile the different interests at the two main urban centres, with visible institutional progress eventually being situated at the symbolic centre, the new capital Ottawa, itself created to reconcile the two communities at Canada's heart.

In Toronto, the Ontario Society of Artists had set itself the goal of establishing a national gallery in its principal objects. The success of its early exhibitions prompted talk in the Toronto press of 'a native School of Canadian Art', Montreal in the 1870s, was suffering a depression, in part the result of a shift in economic activity to Toronto. The Art Association of Montreal, however, survived this lean decade, and opened a new gallery in the city in 1879, inviting the new Governor General, the Marquis of Lorne, to the opening. While debate had previously focused on the possibility – or impossibility – of different regions co-operating in order to develop and improve provision in the arts, Lorne's speech was cast within a vision of the Dominion, suggesting an Academy, modelled on the Royal Academy in London, to take on a national role for the improvement and dissemination of art: 'whose exhibitions may be held each year in one of the capitals of our several Provinces; an academy which may, like that of the old country, be able to insist that each of its members or associates should on their election, paint for it a diploma picture…'[16] and so generate a national gallery.

Such an Academy was brought into being in 1879, by a group drawn from the Art Association of Montreal and the Ontario Society of Artists, with representatives from other Provinces, its first exhibition held in Ottawa in 1880 and then touring to the Art Association of Montreal in Montreal, and the Ontario Society of Artists in Toronto. Lorne had played a guiding role, one he inherited from his predecessor the Marquis of Dufferin, who had been convinced that a distinct national art could evolve; Lorne's wife, Princess Louise, being herself an accomplished watercolourist, ensured that the Governor General saw a national academy and gallery as key elements to create a nation which would contribute to the political urgency of overriding different regional identities.

The pivotal diplomatic figure was the painter Lucius O'Brien, who had become a close acquaintance of Lorne, and was the Royal Canadian Academy's first President. By 1882 the diploma pictures presented in the first Royal Canadian Academy exhibitions, supplemented by works solicited from Lorne's London circle, by Millais, Leighton, Watts and others, were formed into a National Gallery of Canada, opened by Lorne in Ottawa in 1882.

Dufferin's view had been that a national gallery could in large part be constituted by portraits. Art in Britain was dominated by history, genre and symbolist figurative art. Many of the leading artists of Montreal in the last two decades of the century studied in the studios of Paris, still dominated by figurative work, and the first truly successful Canadian artists, mostly working out of Montreal, had explored genre and anecdotal painting, notably Cornelius Krieghoff, Paul Kane and Joseph Légaré.

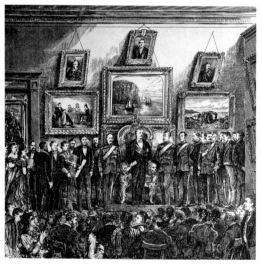

Rideau Hall Lectures. Opening of The Royal Canadian Academy in 1880 by Marquis of Lorne. From Canadian Illustrated News, March 20, 1880. Drawn by L. Dumont

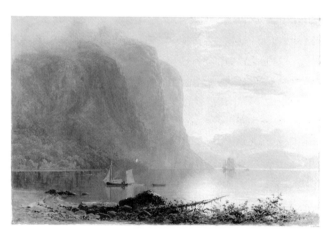

Lucius R. O'Brien, *Sunrise on the Saguenay,* 1880
National Gallery of Canada, Ottawa

O'Brien, however, was one of a body of artists who had attempted to depict the landscape, and continued a long tradition of topographic and romantic image making. O'Brien and his generation possessed a new spirit of optimism that was closely linked to the progress evident in the railway as it forged a way across the country, and the pioneering work of artists associated with photography, particularly the studios of William Notman and his circle, who sought to document and celebrate the spaces made available by the railways. A popular serial publication in the early 1880s, *Picturesque Canada,*

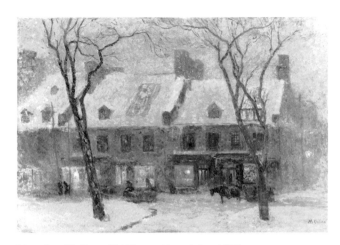

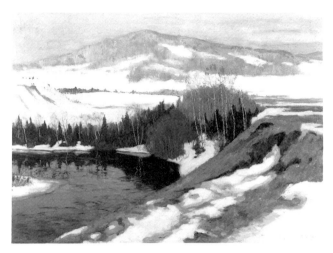

Maurice Cullen, *Old House, Montréal,* c. 1908
The Montréal Museum of Fine Arts Collection (cat. 23)

Maurice Cullen, *The North River,* c. 1932
Art Gallery of Hamilton (cat. 24)

sealed this era, as much as in the poignant irony of the fact of its production by an American publisher and exclusion of Canadian artists as in the way it rounded off a period of celebration of the newly seen land.[17]

O'Brien presented to the National Gallery its first work, as his Presidential diploma piece. The symbolism which we may construe in *Sunrise on the Saguenay* is, however, not wholly an express symbolism of a new dawn for the country. Rather for us it is a telling statement of how bound up O'Brien's grand manner was (despite its small scale) in models of the tradition of nineteenth-century landscape painting, from Turner to Bierstadt.

O'Brien died in 1899. The transition from the situation he left Canadian painting in and the dominant position of the modern painting which the Group of Seven represented was remarkably swift. The whole trajectory was already historicized by 1926, when the widely read *A Canadian Art Movement: the Story of the Group of Seven* appeared, written by an associate of the Group, F. A. Housser.[18]

Housser's account, building on lectures and writings by the Group of Seven artists themselves, created an orthodoxy of how their work came about in the Canadian context, beginning with the kind of work associated with the Royal Canadian Academy of O'Brien's era. 'Before 1910, a Canadian art movement, inspired by Canadian environment, was not thought possible. Canadian art authorities did not believe that our rough landscape was art material…Canadian artists and the Canadian public preferred the softer, mistier, tamer landscape of the old world…'[19]

In Housser's view only the anecdotal work of Krieghoff attempted to be 'Canadian', while two crucial pioneers had realized that Canada, as a new country, had to be painted in the new manner. Housser describes the work of J. W. Morrice, 'our most eminent Canadian artist to date' and his colleague Maurice Cullen as ahead of its time: 'Had [Morrice] appeared as a figure in Canadian art twenty-five years later than he did, his sympathy with the modern movement in painting might have swung him into association with the group of which this book is an appreciation'.[20]

Morrice and Cullen were educated in Paris in the 1880s, and were there infected with a modern sensibility. While O'Brien and his peers were depicting the landscape in an attempt to come to terms with the Canadian landscape within their inherited British academic tradition, this new generation explored painting the landscape out of a new consciousness of it as a vehicle for modernist aesthetic questions.

In 1897, Morrice returned to Montreal to join his family for Christmas. He went painting along the St Lawrence to the picturesque village of Ste Anne de Beaupré, where he joined Cullen. Cullen had also returned to Montreal from Paris, but with the intention of staying awhile and trying to pursue a career as an artist. The works they painted over the winter were shown together at the spring Art Association of Montreal exhibition in 1897: Cullen's *Logging in Winter, Beaupré* (cat.25) and Morrice's *Ste-Anne-de-Beaupré* (cat.98).[21]

In Paris Cullen and Morrice had not spent much time together. Morrice led the life of the flaneur, protected by an allowance from his wealthy Montreal merchant father, and associated with other expatriate avant-gardistes, from Whistler to Henri and Prendergast. The basis for Warren in Somerset Maugham's 'The Magician' and Cronshaw in *Of Human Bondage*, Morrice forged a late impressionist manner, employing the pochade, the small oil on wood panel study, as a way of recording images which fed into worked up paintings in the studio.

Morrice's work on this return visit to Canada pushed along certain tendencies in his painting, notably the impact of white refracted and reflected light. The painting of Ste-Anne-de-Beaupré has been described as the first in which the immediacy of the pochade is achieved in a work on canvas. Cullen, in contrast, experimented with the modern manner in a way that might, in retrospect, be seen as less searching but more immediate in its grasp of painterly devices: *Logging in Winter, Beaupré* seems more mature than *Ste-Anne-de-Beaupré* but in some respects is Cullen's masterpiece, while Morrice was to paint ever more questioning and ever more beautiful works in a range of moods and places over the next thirty years.

This group of paintings are in the words of Dennis Reid 'The first in Canada to bring the tenets of Impressionism to the treatment of Canadian landscape'.[22] They are of a populated landscape, showing everyday activity: sledge driving, a logging team. They remind us that a central tenet of the impressionist project was to paint modern life. Nevertheless the

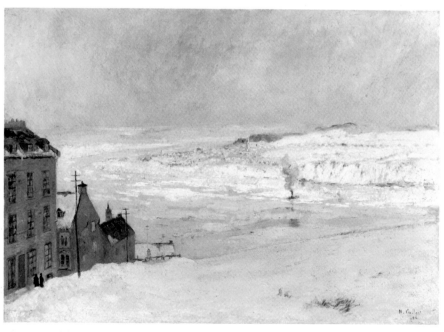

Maurice Cullen, *Levis from Québec,* 1906
Collection Art Gallery of Ontario, Toronto (cat. 22)

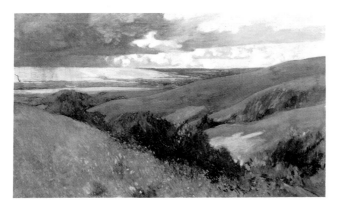

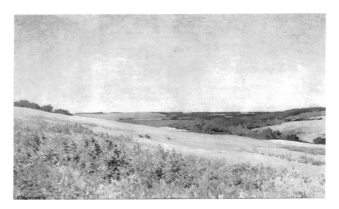

Charles W. (C.W.) Jefferys, *Storm on the Prairies*, 1911
Ms Margaret W. Stacey (cat. 59)

Charles W. (C.W.) Jefferys, *Western Sunlight, Last Mountain
Lake*, 1911. National Gallery of Canada, Ottawa (cat. 58)

contemporary Canadian audience immediately grasped this painting as to do with technique: 'Maurice Cullen, the young artist, whose work is becoming very popular, has a number of winter scenes, treated in the impressionist manner, of in and around Quebec…' 'Maurice Cullen is an impressionist of the modern French school and he paints what he sees…'[23]

It is also frequently remarked that these works are significant for being of snow. The idea that modern artists 'paint what they see' and on the spot (Cullen and Morrice had problems with paint freezing) had liberated the ideological question of what Canadian artists see and paint. The winter landscape had been a vehicle for Krieghoff's popular genre scenes, but not for the serious picturesque art of O'Brien and the academics. In popular imagery, illustration and graphic art, patronage for winter scenes was limited since what was most often required were positive, pleasing images of a landscape which would attract strangers considering living there.

For a generation of young ambitious artists who left Canada to study in Paris, the existing institutions were unsatisfactory. The Ontario Society of Artists and Art Association of Montreal, closely entwined with the Royal Canadian Academy, seemed unable to take on the modern art that this small group of younger artists pursued. In Montreal this precipitated a new artist-led initiative which again wrested the sobriquet 'Canadian', the Canadian Art Club.[24]

The Club was essentially an exhibiting group, on lines that are familiar in the international context. One of the original ideas for their title, 'The New Art Club', their motive to present modern work, installed in a clean, spacious hang, reflects groupings such as the New English Art Club in London and The Ten in New York, who themselves had sought to apply the lessons learnt from the independent exhibitions of new painting in Paris. It is characteristic of their circumstances that they felt it appropriate to add the national tag to their project, to suggest an alternative to other national bodies.

The exhibitions of the Canadian Art Club served to introduce to audiences in Montreal and Toronto a sense of the distinct possibilities of modern painting. The exhibitions were dominated by artists who had spent substantial time in France: Morrice, who continued to live most of the year in Paris, Cullen: Marc-Aurèle Suzor-Coté, and others such as William Brymner whose role as a teacher and organizer was crucial to the Montreal scene over this time.

The nature of their nationalism is ambiguous, however. While in a revealing speech one of its sponsors hoped for the Club to present 'something that shall be Canadian in spirit',[25] many of the contributors found the Club was not worth sustaining with all the struggles necessary to make any headway, Morrice remarking 'I have not the desire to educate the taste of the Canadian public'.[26]

There were, however, in Toronto at the same time artists whose self-appointed task was to take on a new sense of nationalism in art, who in many ways acted as direct mentors to the Group, and who are reduced to, literally, a few footnotes in Housser's account.

Centring on the commercial illustration trades, artists such as C. W. Jefferys, Frederick H. Brigden and Albert Robson were seeking to establish groupings which would generate activity and contact. They recognized that organizations such as the Ontario Society of Arts should be components of a fabric of different structures, formal and informal, that could bind artists together, and bring them into contact with other like-minded practitioners in other fields. They had founded the Toronto Art Students' League in 1886, based on the Art Students' League of New York, to foster the study of drawing, and to promote Canadian subjects. Out of this emerged the Arts and Letters Club, founded in 1904, which embraced the leading writers, critics, dramatists and many political figures as well as painters and illustrators.[27]

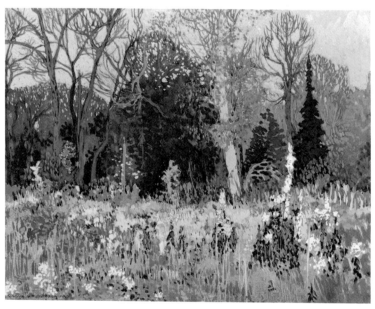

Frank Johnston, *Edge of the Forest,* 1919
Collection of the Winnipeg Art Gallery (cat. 61)

Rooted in English-speaking, loyalist, Protestant Toronto, they were a workmanlike group, whose art took on a straightforward project: to make manifest Canadian subject-matter in resistance both to academic European techniques and illustrative and commercial projects such as *Picturesque Canada.* The Toronto artists were less concerned with modernist trends than the Canadian Art Club, but were more coherently exploring the necessity of establishing what they felt to be a Canadian content in their work, with the circumstantial advantage of all living near to each other, and many following the same profession.

As the railway developed new routes of access into the Canadian landscape to the north and north-west of urban Ontario, they began to sense that this north land was the distinctive Canadian landscape. Throughout the history of depicting picturesque Canada, artists had found problematic the rolling expanse of the prairies and particularly the 'ugly'

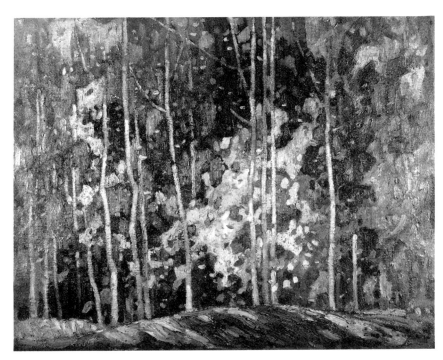

Frank Carmichael, *Fanciful Autumn*, undated
University College, University of Toronto (cat. 4)

landscape of rocky, scrub-covered terrain in the Canadian Shield, with the passages of broken small lakes and enclosed afforested spaces in areas newly designated as national parks such as Algonquin Park.

It was in this context that the Group of Seven emerged, with a burgeoning sense of the possibilities of building on a rich history of depicting the Canadian landscape, together with a consciousness of those Canadians who, while not overtly concerned with developing a national art, were involved in assimilating modernist painting with the Canadian landscape which was the vehicle for their work.[28]

There were three distinct phases in the emergence of the Group of Seven. First, from them meeting in Toronto around 1910-11 and the period of the war, up to 1919. Second, their emergence onto a broader public stage as the Group of Seven, from their first exhibition under that name in 1920 through prominent shows in Canada and in the United States, Britain and France, to their historicization by the appearance of *A Canadian Art Movement: the Story of the Group of Seven* in 1926. Third is the working out of their project from this plateau to their eventual disbanding in 1931 and the formation of what they saw as a successor body, the Canadian Group of Painters, in 1933.

The debate about their status follows these phases. Points of reference are generated in the first period: how they met, what their early influences were, the key role played by Tom Thomson, who died before the Group was formed, and so on. These are then developed into a programme around which reaction formed to the first Group of Seven shows: the role of the National Gallery and a coterie of Toronto patrons in supporting them; how the land represents the nation; their place historically; their relations with other artists such as Carr and Milne. The issues raised over this period then form the agenda for virtually the entire debate about modern art in the country from 1924 until 1939, and indeed in a more historically formed way for the period thereafter when, following the disbanding of the Group, debate continued as a critical question as to their continuing relevance to contemporary practice in the arts.[29]

So, who are the Group? Strictly speaking, they are Lawren Harris, J. E. H. MacDonald, Arthur Lismer, A. Y. Jackson, Frederick H. Varley, Franklin Carmichael and Frank Johnston, who were the original members in 1920 at the first show. As Johnston left he was replaced in 1926 by A. J. Casson. As the Group decided that, in order to spread its message it should have additional members, preferably from other cities, Edwin Holgate from Montreal joined in 1931, and L. L. FitzGerald from Winnipeg in 1932 (after they had originally announced their disbanding). They also asked other like-minded artists to show as invitees: Randolph Hewton, Albert Robinson and Robert Pilot, as Montreal artists in the first exhibition for example. It is generally understood that the central formative personalities were Harris, Jackson, MacDonald and Lismer.

They met through a Toronto printing house, Grip Engraving, run by Albert Robson. In his studio arrived, between 1908 and 1914, MacDonald, Thomson, Lismer, Varley and Carmichael. In 1911 MacDonald held an exhibition at the Arts and Letters Club in Toronto which attracted Harris's attention. MacDonald introduced Harris to his other like-minded colleagues, all of whom were members of the Club.

This exhibition was enthusiastically reviewed by Jefferys: 'MacDonald's art is native – as native as the rocks, or the snow, or pine trees or the lumber drives that are so largely his themes'.[30] In 1912 they were beginning to be described as a distinct tendency, and works by MacDonald and Harris were singled out by the critic Augustus Bridle, a fellow Arts and Letters Club member, as a new attempt to be Canadian: 'Here we have the first satisfying depicture of Canada … Let us hope for more of the same! This is modern and a note of great joy!'.[31] Soon after MacDonald and Harris visited an exhibition of contemporary Scandinavian art in Buffalo, New York. In MacDonald's words: 'Except in minor points, the pictures might all have been Canadian, and we felt, "this is what we want to do with Canada"'.[32]

Practical support as well as a critical context was necessary. In 1913 A. Y. Jackson met the other artists. Harris, with his private means, purchased a painting by Jackson to persuade him not to leave the country. They joined in sharing a new studio building in the city, with Jackson, MacDonald, Thomson and Harris, J. W. Beatty and two others, the more conservative Arthur Heming and Curtis Williamson. Becoming known as The Studio Building, it was financed by Harris and his friend Dr James MacCallum, another Arts and Letters Club member who also purchased a considerable number of the artists' works. They continued to exhibit with growing success. Public purchases also began, often by the newly appointed Director of the National Gallery, its first, Eric Brown, often from their first showings, and often, lest we forget, from established exhibiting bodies: Jackson's *The Red Maple* and a Lismer's, *The Guide's Home*, bought from the 1914 Royal Canadian Academy, Tom Thomson's *Northern River* from the 1915 Ontario Society of Artists.[33]

The war, and Thomson's sudden death by drowning in Algonquin Park in 1917, interrupted but did not divert their steady progress. They decided to form a Group as a final public gesture to capitalize on the attention they had been receiving. In the small pamphlet which accompanied their first exhibition in 1920 they set out a statement of the central tenet of the new group; that they were to make a new art for their country:

'The group of seven artists whose pictures are here exhibited have for several years held a like vision concerning art in Canada. They are all imbued with the idea that an Art must grow and flower in the land before the country will be a real home for its people.

'That this art will differ from the Art of the past, and from the present day Art, of any people; …'

and they set out the premise that they, like all modern artists, will be met:

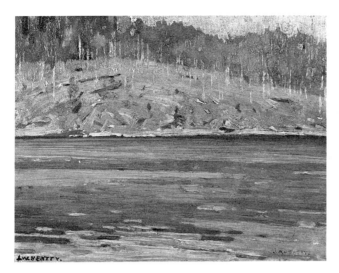

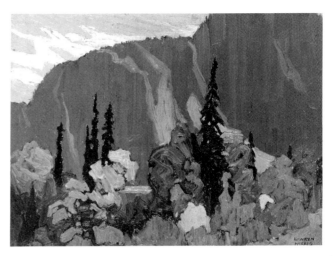

J. W. Beatty, *October, Smoke Lake, Algonquin Park,* undated
Art Gallery of Windsor Collection (cat. 2)

Lawren Harris, *Canyon V. Algoma Sketch XCVI,* c. 1920
The Edmonton Art Gallery Collection (cat.41)

'(1) by ridicule, abuse or indifference

(2) The so-called Art lovers, having a deeply rooted idea that Art is a matter of picture buying through the medium of the auctioneer or dealer, will refuse to recognize anything that does not come up to the commercialized, imported standard of the picture-sale room

(3) The more sophisticated will meet it with: "If you have no traditions, no background, no art is possible"...'[34]

Today one's first reaction on reading this might be: so what? This is forty years on since the Marquis of Lorne's inaugurating the Royal Canadian Academy, since the presentation of *Sunrise on the Saguenay* as the first diploma picture. Moreover, all the evidence suggests that the exhibition was quite appreciatively received. What is clear, though, is that the Group of Seven took on a crucial shift: that this art, like the country, should be new. It should also celebrate the country in a moral and spiritual way. This is achieved through an essentially élitist approach which plays on a mythic – by now a journalistic myth – view of the avant-garde:

'A very small group of intelligent individuals, recognizing that the greatness of a country depends upon three things: "its words, its deeds, and its art"'

who, encountering this new exhibition

'Recognizing that art is an essential quality in human existence they will welcome and support any form of Art expression that sincerely interprets the spirit of a nation's growth.'[35]

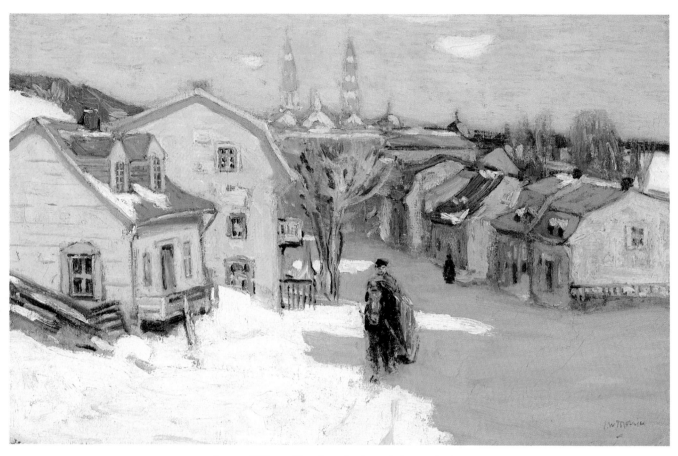

James Wilson Morrice, *Ste-Anne-de-Beaupré,* 1897
The Montréal Museum of Fine Arts Collection (cat. 98)

The extent to which the Group succeeded is evidenced by the exhibitions of Canadian art abroad. Previous to the current exhibition, there have been four major exhibitions of Canadian art in Britain. The most recent, at the Tate Gallery in 1964, featured only post-war abstract and figurative realist painters, but the introduction to the catalogue by R. H. Hubbard began:

'In 1938, when the first exhibition of Canadian art was held at the Tate Gallery, Canadian painting was dominated by the landscape style of the Group of Seven. This Toronto group, formed in 1920, combined in its style elements taken from impressionism, post-impressionism, and Art Nouveau with generous lacings of regional geography and patriotic sentiment. The result proved potent enough to overcome academic opposition, and by 1938 the group's influence had spread to all parts of the country. It its own generation only a few resisted its hegemony'[36]

and he gives David Milne and John Lyman as the two chief personalities who refused to be dominated by the group's influence.

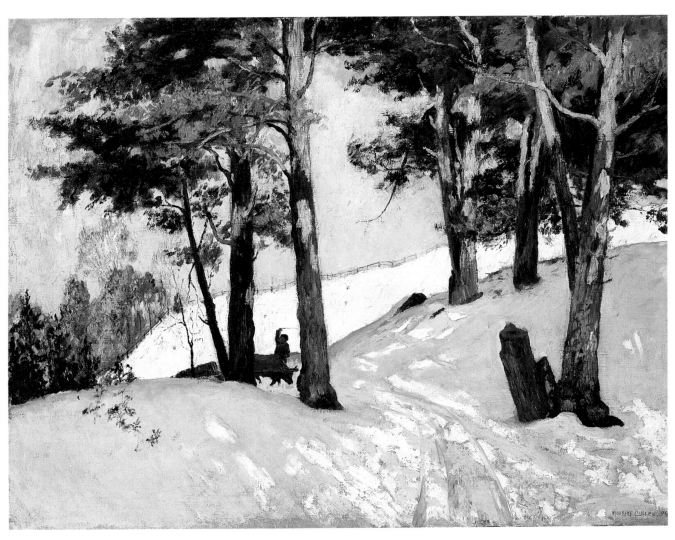

Maurice Cullen, *Logging in Winter, Beaupré,* 1896
Art Gallery of Hamilton (cat. 25)

Indeed, London exhibitions were crucial to the Group trajectory. The first genuine exhibition of Canadian art outside the country, in 1910, is the starting point for Housser's account. The Festival of Empire Exhibition had built on the recent tradition of including art exhibits alongside celebrating the material products of the Empire. Appropriately, the Royal Canadian Academy was invited to present an exhibition of current Canadian art, and it was predictably dominated by the traditional academic, topographic and Barbizon-influenced work which Housser saw as the bulk of Canadian art.[37]

By 1924 the situation was very different. Eric Brown ensured that the selection for the 1924 exhibition was not controlled by the Academy. Instead a small committee, including Group of Seven member Arthur Lismer, chose a show which while broad included a substantial body of work by younger Canadian modernist artists.[38]

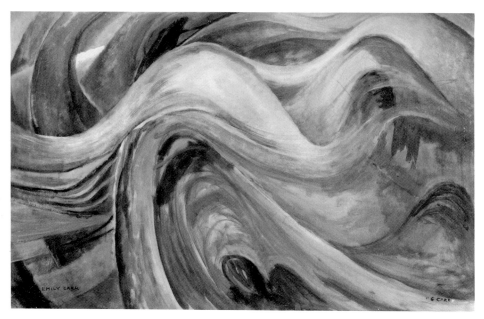

Emily Carr, *Abstract Tree Forms*, c. 1931-32.
Vancouver Art Gallery

The debate which had been building in Canada about the National Gallery's role in supporting new painting, particularly the work of the Group of Seven and their associates, was fuelled by this approach to presenting national art at the Imperial centre. The National Gallery chose both to tour the Canadian art exhibition round Britain, and put together a booklet of excerpts of favourable press coverage to circulate in Canada.[39] This, ironically, played on the sense that the more experienced and aware British critics, more aware than the carping provincials at home, felt positively about the new work:

'Though there has been dispute in Canada as to the representative character of the Canadian paintings displayed in the art section of the British Empire Exhibition there is no doubt that the Canadian work has been very favourably received by English critics.' (*The Toronto Star*)

(compared with the other countries)…'With Canada, however, we are in a happier position. We can sincerely acclaim a vigourous and original art.' (*The Saturday Review*)

Yet a few, for example the *Glasgow Herald*, made their own point:

'That Canada has developed a national school of landscape artists – and this has been asserted – is not at Wembley made plain.'[40]

But the die was cast in Canada. For the rest of the decade the Group continued to set the terms of debate. The Group also, of course, continued to generate some telling paintings to match the stunning impact of its first successful

MICHAEL TOOBY

works. These not only were often acquired for prominent display in the National Gallery, major urban galleries such as the Art Gallery of Toronto, and other public bodies, but were also highly conducive to reproduction. The Group's nationalist intentions were kept alive through the National Gallery touring exhibits to new artist-led and civic institutions which were growing up in the urban centres from Victoria to St Johns, supporting lecture tours (for which Lismer was particularly renowned), and by a succession of publications and debates in the popular press.[41]

Emily Carr's emergence as a significant artist might be described as an instance of how the Group's mission, paralleled by the zeal of the National Gallery and Eric Brown, was evidence of how the programme to establish a national art could succeed. Working in isolation in British Columbia, Carr's painting had doggedly continued until, in 1927, Brown included her in an exhibition at the National Gallery of Canada, of art from the West Coast. Travelling to Toronto and Ottawa, she met the Group, whose example encouraged her to renew her energies. In particular, she found inspiration in the Theosophic vision espoused by Harris which, though relatively short lived, infused a spiritual centre to her extraordinary work from the 1930s.[42]

After the culmination of the debate around National Gallery policy, individual personal factors, particularly the death of J. E. H. MacDonald in 1932, an evident crisis of direction in some of the work being produced; and of course the debilitating impact of the Depression, the Group decided to disband.[43] The Canadian Group of Painters, formed in 1933, could be seen as either a telling image of how many and varied artists had emerged as a result of the Group project, or as a sign that, with the Group of Seven now institutionalized, Canada needed a fresh start and new thinking. This feeling suggested that the time was ripe for surveying Canadian art as a whole, prompting the shape of the 1938 Tate exhibition.

One of the first presented under the Directorship of John Rothenstein, the exhibition had been instigated by the National Gallery of Canada's Assistant Director H. O. McCurry. The latter underwrote the organization of the show, the only costs the Tate having to bear being local publicity. It was obviously valuable for Canadian art to be seen within the Tate itself rather than through the perspective of Imperial exhibitions. However, the imperial flavour, coming as it did in the build

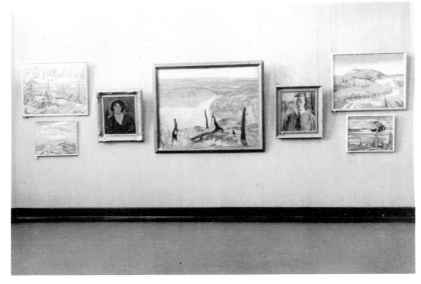

A section of 'A Century of Canadian Art'
at the Tate Gallery, London, 1938

Lionel LeMoine (L.L.) FitzGerald, *Summer,* 1931
Hart House Permanent Collection, University of Toronto (cat. 29)

up to the phoney war, generated a huge amount of press coverage, from its royal opening by the Duke of Kent and subsequent visit by the King and Queen, through critical reviews and photo-features, to reports on the unusually high attendance, at over three times the then average.[44]

In his foreword to the exhibition, the High Commissioner in London, Vincent Massey, wrote how the exhibition showed a long tradition in Canadian art, with the present century characterized by a determination to attempt an interpretation of their country without undue reference to European styles and methods: 'The resulting movement has progressed and has found its inspiration in the brilliance and diversity of the seasons and the variety of the Canadian terrain.'[45]

The Tate's chairman, the Hon. Sir Evan Charteris, pointed to the 1924 exhibition as when Canadian painting 'was formally introduced to Europe' and showed that a rationale for the evident experiment there presented 'may well be sought in the scenery of Canada itself, its range and grandeur, the brilliant light by which it is illuminated, and the violent contrasts which emphasise the seasonal changes to which the land is subject.'[46]

MICHAEL TOOBY

Lionel LeMoine (L.L.) FitzGerald, *Poplar Woods,* 1929
Collection of the Winnipeg Art Gallery (cat. 28)

These words introduced a show which included 35 portraits, 21 figure studies and over 30 works which would be well described as genre scenes of action or narrative. Of the 267 exhibits there were 28 sculptures, 5 examples of antique Quebecois carving, three West Coast Totem poles and a group of Chilkat ceremonial robes. Of the 226 paintings and watercolours, less than half were landscapes, Group of Seven members represented by 34 works, with 7 by Tom Thomson.

Canadian critics chose the moment to affirm that Canadian Art was not necessarily tightly defined as the story of the Group of Seven. Many British reviewers remarked on the consolidation of the achievements in Canadian art since the Wembley Exhibition. The terms in which it was discussed were particular: the landscape agenda created by the Group: 'the characteristic contemporary landscape school…'; '…paintings inspired by the soil and climate…' and so on[47]. Appropriately, this generated the most important critical factor, the problem of placing this agenda within that of contemporary Britain.

James E.H. (J.E.H.) MacDonald, *Leaves in the Brook, c.1918*
McMichael Canadian Art Collection (cat. 67)

Eric Newton wrote that (the works) 'are with a few exceptions, indigenous in the truest sense of the word, a direct growth from the soil and climate of a country that has very little similarity to England',[48] and while critical, Jan Gordon summed up that 'Canada has managed to evolve a school of landscape painting which has a very definite character, different from those developing in Europe and the United States, and this, in these days of standardisation, must be considered no mean feat.'[49] In response to Herbert Read's dismissive article, a correspondent wrote, 'two vital national schools have emerged in the New World without the burden of the international style; the Mexican and the Canadian'.[50]

The present exhibition ends in 1939. In the year in which war broke out, the reaction in Montreal away from the nationalist, programmatic art which had dominated Canada for a generation was taking form in the initiation of the Contemporary Art Society. This sought to restore the passive, aesthetic dimension of modern painting. Writing in 1940, its moving personality, John Lyman, responded to an article by Barker Fairley, a close associate of the Group of Seven who had posed a question which for many had become critical: now that the moment of landscape painting seemed to have passed, what will replace it, and how will it be Canadian? Lyman concluded: 'Today painters are off the bandwagon. They know a northern lake is really no more Canadian than a nude painted by the same artist. And if it takes a bandwagon to shake people out of the view that man is not so well painted in Canada as nature, it will be a long time before they see much of him. They will first have to want to see pictures in which the emotional stimulus is one that properly belongs to the medium.'[51] The international abstract painting which became as automatically associated with Canada in the 1950s and 1960s as was the Group of Seven in the 1930s was being ushered in.

MICHAEL TOOBY

James E.H. (J.E.H.) MacDonald, *Leaves in the Brook,* 1919
McMichael Canadian Art Collection (cat. 68)

NOTES

References are made so as to assist further reading. A full bibliography is not given since much of the material is unavailable in the United Kingdom. The author will be pleased to give further references.

1. Canadian National Anthem, words by Robert Stanley Weir, 1906, see entry in *Encyclopedia of Music in Canada,* eds, Kallman, Potvin & Winters, Toronto 1981.
2. There is a large body of material on this subject in addition to those references made here. Some broad introductions are: Ramsay Cook, *The Maple Leaf Forever, Essays on nationalism and politics in Canada,* Toronto 1971; Peter Russell, ed., *Nationalism in Canada,* Toronto and Montreal 1966; *Se Connaître: Politics and Culture in Canada,* Toronto 1985. In addition to the essays by Frye cited below (note 15) another literary collection which gives many insights into the subject is Margaret Atwood, *Survival: A Thematic Guide to Canadian Literature,* Toronto 1972. The essays in *O Kanada,* Akademie der Kunst, Berlin 1982-83, are helpful.

3. In a popular book *Great Canadians: A Century of Achievement*, published by MacLelland & Stewart and *Weekend Magazine* in 1965, the distinguished selection committee admitted that on the first round of debate on who were great Canadians, the only two unanimous choices were the discoverer of insulin, Frederick Banting, and Emily Carr, with Tom Thomson coming in the next round of proposals.

4. Many reviews of post-war Canadian art in Britain have been framed in this approach, see John Russell Taylor, 'Canadian Art in London: a curious rag-bag', in *Canadian Art*, 2, no. 2 (June 1985).

5. See for example, Ramsay Cook with John Saywell & John Ricker, *Canada: A Modern Study*, Toronto 1971.

6. See for example, Arthur Lismer's texts on Canadian art, summed up in 'Canadian Art', *The Canadian Theosophist*, V, no. 12, 1925.

7. For a general introduction to Canadian history see Craig Brown, ed., *The Illustrated History of Canada*, Toronto 1987.

8. Two exhibitions have examined the relation between the United States and Canada, and their catalogues include references to further reading: Christine Boyanoski, *Permeable Border: Art of Canada and the United States 1920-1940*, Art Gallery of Ontario, Toronto 1989, and Ann Davis, *A Distant Harmony*, Winnipeg Art Gallery 1982.

9. See note 1.

10. See notes 2 and 5.

11. *E.g.* in the popular book *Canadian Life and Scenery, with hints to emigrants and settlers*, by the Marquis of Lorne, London 1898, This persisted into children's geography books in the 1950s and early 1960s.

12. Cited in Brown, *ibid.* note 7, p.383.

13. See Ramsay, Cook *Canada, Quebec and the uses of nationalism*, Toronto 1986.

14. Carl Berger, *The True North Strong and Free*, in Russell, cited note 2.

15. Northrop Frye: 'Canadian and Colonial Painting', repr. in Frye: *The Bush Garden: Essays on the Canadian Imagination*, Toronto 1971. In my view this is the best introduction to the issues surrounding Canadian culture.

16. Quoted (p.274) in the rich account of this generation by Dennis Reid, *Our Own Country Canada: being an account of the national aspirations principal landscape artists in Montreal and Toronto, 1860-1890*, National Gallery of Canada, Ottawa 1979; see also the recent catalogue for the exhibition organized by Dennis Reid, *Lucius R. O'Brien: Visions of Victorian Canada*, Art Gallery of Ontario, Toronto 1990.

17. *Picturesque Canada* appeared as a serial between 1880 and 1884, published by the American Belden brothers, itself part of a series that began with *Picturesque America*, and included *Picturesque Europe* and others. The controversy over O'Brien's involvement in the project is described in Reid's two publications cited above. For a point of comparison see Stanley Triggs, *William Notman, The Stamp of a Studio*, Art Gallery of Ontario, Toronto 1985, which describes the fascinating and beautiful work of the famous Canadian photography studio.

18. F.B. Housser, *A Canadian Art Movement: The Story of the Group of Seven*, Toronto 1926.

19. *Ibid.* p.11.

20. *Ibid.* p.22.

21. See Sylvia Antoniou, *Maurice Cullen 1866-1934*, Agnes Etherington Art Centre, Kingston 1982, and Nicole Cloutier: *James Wilson Morrice 1865-1924*, Montreal Museum of Fine Arts 1985.

22. Dennis Reid, *A Consise History of Canadian Painting*, Toronto (2nd ed.) 1988, p.127.

23. Antoniou, *ibid.*

24. See Robert J. Lamb *The Canadian Art Club 1907-1915*, Edmonton Art Gallery 1988.

26. Cloutier, *ibid.*

27. A history was written by Bridle, *The Story of the Club*, Toronto 1945, see also note 29.

28. The Canadian Shield is the geological feature which gives the northern Ontario and Quebec landscape its distinction. Algonquin Park and Georgian Bay, two places explored by this generation, lie on its edge. There are important texts setting out this orientation of the history of the period, notably William Colgate, *Canadian Art: Its Origins and Development*, Toronto: Ryerson Press 1943, repr. in paperback form in 1967. See also the seminal text by Albert H. Robson himself, *Canadian Landscape Painters*, Toronto 1932, and Robert Stacey's essay in *Charles William Jefferys 1869-1951*, Agnes Etherington Art Centre, Kingston 1976.

29. The two standard publications on the Group of Seven are: Peter Mellen, *The Group of Seven*, Toronto 1970, and Dennis Reid, *The Group of Seven*, National Gallery of Canada, Ottawa 1970, which was accompanied by *A Bibliography of the Group of Seven*, by the same author, pub. 1971. A recent text by Dennis Reid, *The Group of Seven: Selected Watercolours, Drawings, and Prints from the Collection of the Art Gallery of Ontario*, Art Gallery of Ontario, Toronto 1989 is of note, while in *Canadian Masters from the Collection of the Power Corporation of Canada: 1850-1950* there is an interesting text: 'Landscape Painting in Canada', by Laurier Lacroix, Musée du Séminaire de Québec, Canada 1989. A good introduction is Joan Murray's *The Best of the Group of Seven*, Edmonton 1984.

30. C. W. Jefferys, 'MacDonald's sketches', *The Lamps* (the magazine of the Arts and Letters Club), December, 1911.

31. Quoted in Housser, *ibid.*, cited in note 12, p.47.

32. J. E. H. MacDonald, in a lecture on Scandinavian art given in 1931. Though widely quoted, this lecture is not often seen in full. It is given in full with a commentary by Robert Stacey in *Northward Journal*, no. 18/19, November 1980. Roald Nasgaard's *The Mystic North*, Art Gallery of Ontario, Toronto 1984, is an essential study of the links between the painters of the Canadian north and Scandinavian and European artists of comparable sympathies.

33. See Reid, 1970. The patronage of the Group is a complex subject, Brown had been appointed by Sir Edmund Walker, an acquaintance of Harris; Harris came from the wealthy family of industrialists whose firm

became known as Massey-Harris when it merged with that owned by another powerful Canadian dynasty, Massey. Vincent Massey, who figures later in this account, attended the same school as Harris and was an Arts and Letters Club member. For an account of how the Arts and Letters Club spawned another crucial point of patronage and critical support, Hart House in the University of Toronto, see Catherine D. Sidall, *The Prevailing Influence: Hart House and the Group of Seven, 1919-1953*, Oakville Galleries, Toronto 1987.

34. Fascimile of the first *Group of Seven* catalogue produced by the National Gallery of Canada, Ottawa 1970.

35. *Ibid.*, see my note on one source for the quotations in *Our Home and Native Land : Sheffield's Canadian Artists*, Sheffield Arts Department 1991.

36. Hubbard, introduction in *Canadian Painting 1939-1963*, the Tate Gallery, London. 1964.

37. The 1910 exhibition was actually mounted at the Walker Art Gallery, Liverpool, even though the Royal Canadian Academy had intended it for the Empire Exhibition at the Crystal Palace; the project was curtailed by the death of Edward VII.

38. In addition to Charles C. Hill's account here, see also Mellen (1970).

39. 'Press Comments on The Canadian Section of Fine Arts, British Empire Exhibition', National Gallery of Canada, Ottawa 1924-25.

40. *Ibid.*

41. Lismer's texts and lecture tours after 1933 form part of the study of his late work in *Canadian Jungle* by Dennis Reid et al., Art Gallery of Ontario, Toronto 1983.

42. The available introductions to Emily Carr include: Doris Shadbolt, *The Art of Emily Carr*, Vancouver 1979 and the same author's *Emily Carr*, Vancouver 1990; Maria Tippett, *Emily Carr: A Biography*, Markham, Ontario 1985. See also *Vancouver: Art and Artists 1931-1983*, Vancouver Art Gallery 1983 and 'Emily Carr, Canadian Modernist' by Ruth Stevens Applehof in *The Expressionist Landscape: North American Modernist Painting*. Birmingham Museum of Art, Birmingham, Alabama (catalogue distributed by University of Washington Press, Seattle) 1988.

43. See Charles C. Hill, *Canadian Painting in the Thirties*, National Gallery of Canada, Ottawa 1975.

44. Exhibition file and press cuttings album, Tate Gallery Archive, London.

45. *A Century of Canadian Art*, Tate Gallery, London 1938.

46. *Ibid.*

47. Tate Gallery cuttings album, Tate Gallery Archive, London.

48. *The Sunday Times*, undated cutting, Tate Gallery Archive, London. Newton regularly lectured in Canada.

49. *Christian Science Monitor*, 1 November 1938.

50. Maxwell Bates, *The Listener*, undated cutting, Tate Gallery Archive, London.

51. John Lyman 'Art' column, *The Montrealer*, 1 January 1940. Barker Fairley was a friend of the Group of Seven artists from the early 1920s, and his writings in *The Canadian Forum* form a central body of texts for understanding the artists, while Lyman's writings, witty and acerbic, form an equally important opposite pole. That writing by both is inaccesible in publishing terms is ironic testament to the amount that remains to be done for the serious consideration of this most public of moments in art history.

Tom Thomson, *The West Wind,* 1917
Collection Art Gallery of Ontario, Toronto (cat. 113)

ROBERT STACEY

THE MYTH – AND TRUTH – OF THE TRUE NORTH

Art changes. Where is now the sickly sky
Mottled with dirty brown, topped with a slant
Of sticky orchreish yellow. Who will rant
To-day of the Old Masters? Rather cry
The needs of these new men who 'schools' defy
To paint the things they see, the living plant.
Root, branch, *in toto*…

Art changes. See the foursquare canvas flare,
Flickering with colour; watch the sunset blaze
Through greyish wisps of evening's tangled hair.
The Truth shall make them free, the truth they implore,
A Constable or Crome could do no more.

S. Frances Harrison ('Seranus'), 'To the New Art' (1922)

The more art changes, the more it stays the same. Art-facts become art-folklore within living memory; art history is a kind of scar-tissue of conflicting 'evidence'. Every culture, whether provincial or cosmopolitan, is a product of this process of transformation and accretion. In their haste to become old, young nations tell lies themselves that turn into necessary truths.

Canada's puritanical founders, unfortunately, thought 'myth' and 'lie' were synonyms, and so proscribed the former while living the latter – thereby inventing an ironic national mythology of their own. But did not Ambrose Bierce, in his *Devil's Dictionary*, define 'Mythology' as 'The body of a primitive people's beliefs concerning its origin, early history, heroes, deities and so forth, as distinguished from the true accounts which it invents later'? Joseph Campbell called myths 'life-supporting illusions'. 'The American writer Paul Metcalf interpreted '*myth*…not as something different from truth, bus as *essential* truth'.

There is no myth (or truth?) more essential to Canada's shaky sense of identity than the conviction that it represents, as the national anthem contends, 'the True North'. (The 'strong and free' boast, on the other hand, is the subject of considerable debate.)

Another operative myth of Canada is that it is, as the poet Douglas LePan suggested, 'A Country Without a Mythology'. Self-evidently false as this fantasy in mythlessness might be, it has required endless correctives, the citation and disregarding of which are as ritual as the repetitions of the fable itself. Protestations become self-fulfilling prophesies; denial breeds confirmation.

A third and related national myth was posited by the poet Earle Birney in the concluding couplet of his notorious lampoon. 'Can. Lit.', written in 1962: 'no wounded lying about, no Whitman wanted. It's only by our lack of ghosts we're

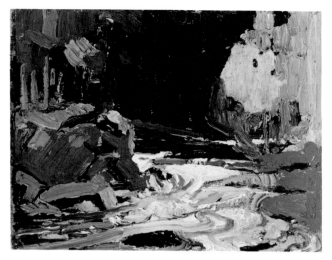

Tom Thomson, *Winter, Study for Afternoon, Algonquin Park,* c. 1914
McMichael Canadian Art Collection (cat. 108)

Tom Thomson, *A Rapid,* undated
Collection Art Gallery of Ontario, Toronto (cat. 117)

haunted.' To which dismissal the novelist Robertson Davies somewhat plaintively replied in 1964: 'No ghosts in Canada?' In his attempted reversal of the no-ghosts, no-mythology myth, Davies made claims for the unheralded 'Canadian writers of the past' which are equally applicable to the painters of roughly the same period: 'In the land which pretends to have no ghosts, they have seen ghosts; in the country without a mythology, they have heard the ground bass of myth; in a country born not of love and struggle but of politics, they have fought battles; and, with reserve and irony, they have offered their country love.'[1]

A hint of the sway that the idea of Canada projected by the twentieth-century artists who most publicly 'offered their country love', the Group of Seven, continues to exercise over the English-speaking Canadian imagination is suggested in a recent Margaret Atwood short story. It describes a modish Toronto apartment's display of

'blocks of . . . paintings, or sketches and drawings, by artists who were not nearly as well known when Lois began to buy them as they are now. Their work later turned up on stamps, or as silk-screen reproductions hung in the principals' offices of high schools, or as jigsaw puzzles, or on beautifully printed calendars sent out by corporations as Christmas gifts to their less important clients. These artists painted after the first war, and in the Thirties and Forties; they painted landscapes. Lois has two Tom Thompsons [*sic*], three A. Y. Jacksons, a Lawren Harris. She has an Arthur Lismer, she has a J. E. H. MacDonald. She has a David Milne. They are pictures of convoluted tree trunks on an island of pink wave-smoothed stone, with more islands behind; of a lake with rough, bright, sparsely wooded cliffs; of a vivid river shore with a tangle of bush and two beached canoes, one red, one gray; of a yellow autumn woods with the ice-blue gleam of a pond half-seen through the interlaced branches.'[2]

The implication here is that all upper-middle-class, middle-Canadian urban households are furnished with such instantly recognizable and self-affirming possessions, decades after the original buyers had acquired these once-controversial, now blue-chip tokens of wise investment. For a British equivalent of this assumption, the Glasgow School, the

New English Art Club or the Camden Town Group would have to be posited as *the* 'national' art movement, not only for its own time but for perpetuity.

If the Group of Seven's *œuvre* has long since become domesticated and commodified, it should be remembered that, in their heyday, these artists sought to shed the complacency and timidity that had shackled their counterparts of the two generations before their own. Before their enshrinement as institutions, these latter-day *fauves* were viewed by conservatives as dangerous lunatics, and by liberals as needed rebels who alone could salvage the reputation of the chronologically young but culturally sclerotic Dominion. Their red-maple badge of courage was awarded them by posterity for daring to praise the North when it was still perceived as a barren, inhospitable void: '*Aca-nada*', the Portuguese fishermen's 'nothing here', the no-man's-land the explorer Cartier believed 'God gave to Cain', the 'God-forsaken country called Canaday-i-o' of the lumberjacks' folk song.

Even to their friends these men (several of them recent immigrants from Britain) were strangers in an estranged land, 'Going among this savage people' unguided by 'monuments or landmarks'. To their enemies they must have seemed like that 'lust-red manitou' who, 'clumsily contrived, daubed/with war-paint', teeters through the forest of LePan's above-mentioned poem. Both extremes are mocked by the auction-room records Group of Seven canvases continue to set, and by their ubiquity in the boardrooms of the corporations whose wealth derives from stripping the natural assets from the 'Great Canadian Outback' that was the inspiration and occasion of those very pictures.

In the face of such contradictions, the legends thrive, divide and multiply. The axiom that, just as truth can be stranger than fiction, myth is stronger than history – rather, *is* history – needs constant reiteration. For the Group of Seven, the mythification began early, with the appearance in 1926 of F. B. Housser's *A Canadian Art Movement: The Story of the Group of Seven*, a scant six years after the confederacy's first joint exhibition in 1920. In a letter to Housser which he elected not to send, J. E. H. MacDonald, the senior member of the Group, commented that the book made him realize the cynical truth of Napoleon's saying that 'all history is a lie agreed upon': 'It seems impossible to state things exactly as they were… The historian has to deal with documents and memories. The documents are the best material if written at the time.

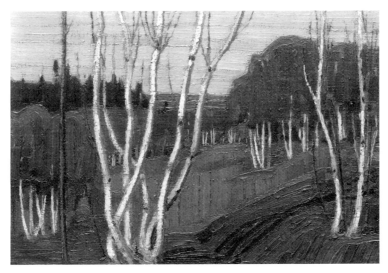

Tom Thomson, *Silver Birches,* c.1914
McMichael Canadian Art Collection (cat. 107)

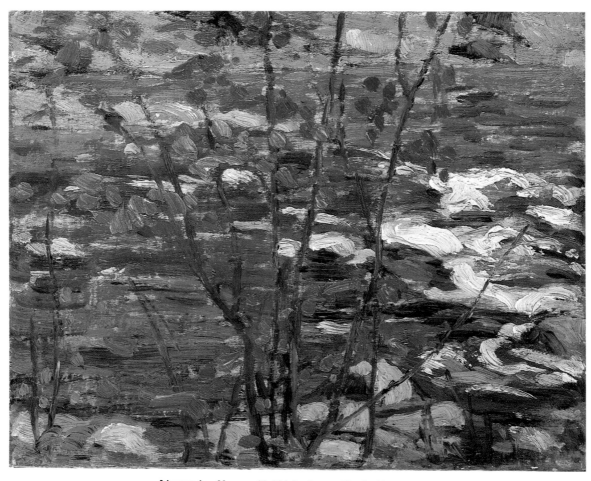

Alexander Young (A.Y.) Jackson, *The Red Maple,* 1914
McMichael Canadian Art Collection (cat. 49)

Memories put a haze around things which falsify them, or at all events *poeticize* them…Things should be reflected as they were and not as they appear in the light of Cezanne or Roger Fry.' MacDonald's chief criticism was that Housser had treated the Group as *sui generis,* rather than striving to 'give things their proper order and sequence. It seems to me that the stage is not properly set in the beginning.'[3]

The desire to dispel the mist of untruths, half-truths and truisms that enshrouds the actual achievement of the Group of Seven should not be construed as yet another act of smug post-modernist revisionism. In the present context, the project of deconstructive analysis of a national cultural myth is surely a self-defeating one, considering the obscurity of the artists in question outside of Canada. My interest in a more balanced and objective account stems, rather, from a conviction that the Group's best work is even more remarkable than the most generous of the British Empire Exhibition critics ventured on their first cognizance of these artists in 1924. Perhaps *The True North* will do something to support that view, and even go so far as to validate C. Lewis Hind's startling statement that 'These Canadian landscapes…are the most vital group of paintings produced since the war – indeed, this century.'[4]

ROBERT STACEY

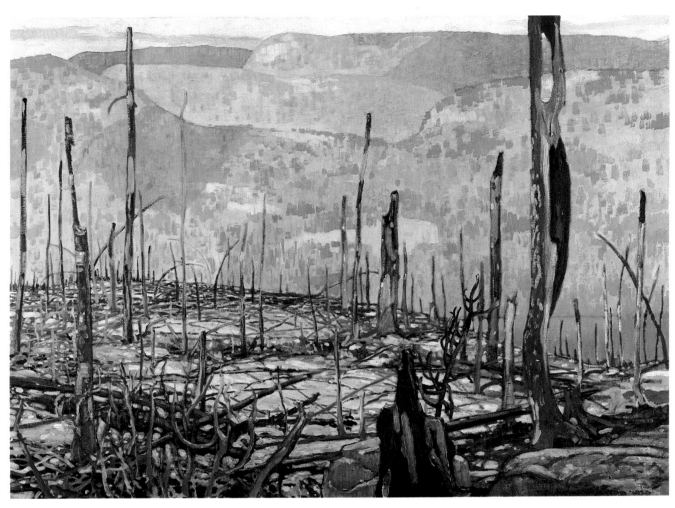

Frank Johnston, *Fire Swept, Algoma,* 1920
National Gallery of Canada, Ottawa (cat. 62)

Unfortunately, the difficulty of setting the record straight is compounded by the fact that the basic story itself has only partially been told, and then only for domestic consumption. Of late, much of the most salutary work in this field of investigation has been undertaken by social historians, literary critics and cultural geographers. These non-art-experts have come to realize that no understanding of the intellectual makeup of Canada can be achieved without an assessment of the pictorial record, its economic and ideological sources, its distribution, its marketing, and its reception.

As MacDonald hinted, one of the first quandaries that confronts the sincere de-mythifier is the lack of consensus about the chronology of the movement and its antecedents. Although the Group of Seven's champions made much capital of the alleged 'radicality' of its programme, the same aesthetic and geographical imperative had been advocated for nearly half a century before. One could cite any number of pantheistic wolf-howls responding to the 'call of the wild' at the height of the very era against which the Group and its followers professed to be in rebellion: the era personified by Queen

Victoria's *locum tenens*, the Marquis of Lorne. Yet it was this poetical and artistically talented Governor General who had proclaimed, before the gathered throng at the opening of the Art Institute of Montreal in 1879, his conviction that:

'[I]f legendary and sacred Art be not attempted, what a wealth of subjects is still left you, – and if you leave the realm of imagination and go to that of Nature which you see living and moving around you, what a choice is still presented …[I]n the scenery of your country, the magnificent wealth of water of its great streams; in the foaming rush of their cascades, overhung by the mighty pines or branching maples, and skirted with the scented cedar copses;…in the sterile and savage rock scenery of the Saguenay – in such subjects there is ample material, and I doubt not that our artists will in due time benefit this country by making her natural resources and the beauty of her landscapes as well known as are the picturesque districts of Europe, and that we shall have a school here worthy of our dearly beloved Dominion.'[5]

Nearly five decades after this prophesy of the rise of a national landscape school, Lawren Harris could pretend there were still something revelatory, if not revolutionary, in his pronouncement that the 'North' instilled itself in the Canadian artist's 'outlook' through 'the bodily effect of the very coolness and clarity of the air, the feel of soil and rocks, the rhythms of its hills and the roll of its valleys, from its clear skies, great waters, endless little lakes, streams and forests, from snows and horizons of swift silver.'[6] As the Canadian geographer Brian S. Osborne has noted:

'These were the defining themes of the Group of Seven: rock, rolling topography, expansive skies, water in all its forms, trees and forests, and the symbolic white snow and ice of the 'strong North'.
Whatever its lineage, the work of the Group of Seven came to dominate Canadians' self-images, or at least, the images of their country. An ideology of Northern distinctiveness became central to the iconography of Canadian landscape.'[7]

This 'ideology', however delusive, became central to the 'self-images' of Canadians long before the Group made its iconography truly iconic. The Group's ability to position itself strategically as the exemplars of 'Northern distinctiveness' owed as much to the growth of nationally comprehensive media – including radio and documentary films – as to the determinism implicit in Harris's philosophy of Canadian-ness as a function of nordicity, and of the 'Virgin north' as a source of spiritual 'replenishment'. The mechanical reproduction and broadcast of pictures by (and of) these heroic figures served to impose their vision on the nation no less than did the North, according to Harris's theory, impose its values (both painterly and 'eternal') on the artist.

In 1933, the year the Group disbanded, a University of Toronto professor of philosophy, Reid McCallum, published one of the first attempts to place this exhibiting collective in context, and to winnow meaningful myth from mere wishful thinking. 'The artists themselves', he noted,

'probably rightly, have largely refrained from explaining what they are doing, being too busy doing it. At most, in the heat of controversy, one finds politico-geographical terms such as "Canadian Art". "Canadianism", "The Canadian North", or Lawren Harris's "The North" bandied back and forth, denied, or asserted to characterize the new movement in its essence. In the heat of controversy the use of terms intelligible to the public precisely because they

Tom Thomson, *Log Jam,* c. 1915
McMichael Canadian Art Collection (cat. 109)

are not art terms served a useful purpose in drawing attention to the fact that Canada now harboured eminent painters of her own doing excitingly original work; but the fact remains that the language of politics or geography is as unsuited as that of arithmetic to formulate the essence of an art.'

MacCallum acknowledged, however, that

'like most well-meant propaganda in a good cause, this talk of Canadianism has created myths which stand in the way of a proper appreciation of the movement. Take the case of that great, and in some ways solitary genius, Tom Thomson. The public has eagerly seized him and built up a myth about him. He has become a national, even a political, symbol of our recent emergence from political tutelage. For here, against a general background of effete academies, especially the Royal [Canadian] Academy, arises a true earth-born artist, untouched by the past, untutored and unspoiled, who depicts Canada in an idiom which is genuinely Canadian, who brings the fire down from heaven in a new land and founds a flourishing national school. It is a curious revenge of facts upon this quasi-political legend that its originators ingenuously take the universal success of the Canadian pictures at Wembley [in 1924] as the climax of their little drama.'[8]

Among the more obstinate of the standard myths is the dictum that, as P. G. Konody had asserted in 1925, the Group's 'lost leader', Tom Thomson, was 'the artistic "discoverer" of Canadian landscapes,'[9] in particular that of the Northern Ontario 'bush'. An artistic discoverer Thomson truly was, but neither he nor the Group could be said to have 'discovered' the North, at least in the sense of exploring and appreciating it first, even among the palefaced late-comers who usurped the homelands of the original Canadians.

J. W. Beatty, *Beech Tree,* 1916
Hart House Permanent Collection, University of Toronto (cat. 1)

One of the key perpetrators of the 'discovery' half-truth/half-myth was the aforementioned Toronto lawyer, journalist and Theosophist, F. B. Housser. Housser is correct in stating that, with the Group's exposure to the spectacular 'Algoma country' after the First World War, 'began a procession of exhibitions across the continent in which thousands of Canadians saw for the first time on a large scale a "Canadian statement in art".'[10] But his hagiography errs in its rejection of all earlier recognitions that 'The North, like the West…is "an indication of ourselves"', and that its true expression in paint 'demands the adapting of new materials to new methods'.[11]

To begin with, there is the basic question of what, exactly, constitutes 'North'. As Margaret Atwood says, 'The north…is relative'. A glance at the atlas reveals that the terrain still most associated with the wide-ranging Group of Seven, the southernmost extension of the granitic Pre-Cambrian or Laurentian Shield that girdles the northern half of the subcontinent, are regions lying between the same 45th and 50th parallels that run through the middle latitudes of Europe. When Arthur Lismer and Fred Varley emigrated from Sheffield to Toronto in 1912, they came *south* as well as west. 'It is not

ROBERT STACEY

Tom Thomson, *Snow in the Woods,* c. 1916
McMichael Canadian Art Collection (cat. 112)

generally realized', wrote Wyndham Lewis in 1948, 'how a relatively short distance north of the cities strung out across Canada in a wavering line the "bush", the wilderness, begins, with its multitudes of lakes and streams.'[12]

Further, south-central Ontario's share of these nether regions (now touristically designated 'the near North') had been intensively explored by artists for some decades before the Group arrived on the scene. Most of the 'Highlands of Ontario', as homesick Scottish settlers had dubbed their rugged new homeland, had been mapped, surveyed, timbered-over, mined and settled at least half a century before the arrival of proto-modernist painters on the scene. But then, the English Lake District was itself not 'discovered' by seekers after the Picturesque until the late eighteenth century – thanks in part to the Rev. William Gilpin's *Lake Tour*, widely circulated in manuscript before its publication in 1786, and to its literary

successor, Wordsworth's *Guide to the Lakes*, published in 1810. The latter's Canadian counterpart was W. W. Campbell's *The Canadian Lake Region*, which appeared exactly one century later; a revised edition came out in 1914.

In the light of such dates, it should be noted that the French River down which Tom Thomson paddled solo from Algonquin Park to Lake Huron's Georgian Bay in the spring of 1914 had been a major thoroughfare for the native Algonkians since pre-Columbian times, a fur-trade highway since the traverses of Samuel de Champlain and Étienne Brulé in 1615 and Alexander Henry in 1761, its mouth a commercial fishery since the first half of the nineteenth century, its several channels a timber-drive route since the 1880s, and its entire length a prospective ship canal since the 1890s – not to mention a favoured haunt of hunters, fishermen and canoeists. Like Thomson, these sportsmen were comparative parvenus: one of the first delineators of this mazy watercourse, Maj. John Elliott Woolford (1778-1866), a British army topographer, had painted watercolour records of a descent of the river he made with his patron, Lord Dalhousie, in 1821.

John Elliott Woolford, Fall of the Grand Recollet, French River, watercolour, dated 1824 on mount, but probably 1821. Collection, Canadian History Department, Metropolitan Toronto Library

Highland Inn, Algonquin Park, overlooking Cache Lake, c. 1913. This hotel was built in 1908-10 by the Grand Trunk Railway, operated by the Canadian National Railway until 1928, and demolished in the mid-1950s. Collection, National Archives of Canada, Ottawa

Although the painters who, as early as the 1860s and 1870s, had descended upon the nearby Muskoka, Haliburton and Kawartha Lakes districts, were prevented from turning their attention to the Algonquin Park area on account of its relative inaccessibility, the new century brought waves of *plein-air* sketchers into these once-remote reaches. The first to suggest its artistic promise were three members of the Toronto Art Students' League, David F. Thomson (no relation to Tom), W. W. Alexander, and Robert Holmes, who explored the recently designated provincial park in the summer of 1902; they were soon followed by J. W. Beatty, T. W. McLean and H. B. Jackson. All of these artists were commercial illustrators, engravers or lithographers by day, and it was at Toronto's leading 'art house', the famous Grip Ltd., that Tom Thomson and the proto-Group – J. E. H. MacDonald, A. Y. Jackson, F. H. Varley, Arthur Lismer, Frank Johnston and Franklin Carmichael – first heard from McLean about the splendid canoeing, fishing and sketching to be had in the Park. 'By 1912', the year of Thomson's first visit, 'Algonquin Park was well known in Toronto as ideal painting territory.'[13] It was Thomson and his comrades, rather than their precursors, however, who found themselves being labelled 'the Algonquin School'.

ROBERT STACEY

Our pictorial explorers were treading well-marked paths. As Park historian Audrey Saunders relates:

'Beginning in 1818, and continuing for the next fifty years, the Algonquin Park country had its share of canoe-trippers, who passed to and fro along the Park highways. These travellers were sent there for specific purposes. There were army officers seeking transportation routes to bases on Lake Huron and Lake Superior; there were government and private surveyors sent to report on the soil and vegetation of the region, and to trace out the courses of the many rivers flowing out of this height of land.'[14]

Concerns for the conservation of this resource-rich domain came to a head in 1886, when Alexander Kirkwood, the chief clerk in the Land Sales Division of the Ontario Department of Crown Lands, wrote a letter to his commissioner, the Hon. T. B. Pardee, which he published in pamphlet form, advocating the establishment of a National Forest and Park in the upland region between Lake Huron and the Ottawa River. The purpose of this reserve would be 'the preservation and maintenance of the natural forest', and the protection of 'the headwaters and tributaries of the Muskoka (Oxtongue), Petawawa, Bonnechère and Madawaska Rivers'. This proposal was given impetus by the appearance, also in 1886, of James Dickson's *Camping in the Muskoka Region*, the first full-length description of the area. Dickson's introductory chapter opens with a revealing proposition:

'In these days of steamboats, railroads, tourists and newspaper correspondents, one would think that there ought to be a few spots now in this Ontario of ours a *terra incognita*; few spots which either the pen of the traveller has not described or the pencil of the artist illustrated and brought vividly before the mind's eye of those who have not had the opportunity of seeing for themselves. Still there are many grand scenes of lake and river, of mountain and valley, of wimpling burn and brawling brook, of lovely forest glade and fern-fringed dell, that have neither been described nor illustrated.'[15]

Kirkwood's contention was that, 'while the descriptive powers of so many pens and pencils have been employed in describing the magnificence of that vast country' (i.e. 'our great North-West') 'there are scenes of equal, if not greater, beauty almost at our doors…' 'Come with me', he bade, 'and we will spend a summer holiday in this sylvan retreat, where, though we can reach it in a few hours' travel, we will be comparatively cut off from the busy haunts of men.'[16]

Although ostensibly to provide 'A public park, and forest reservation, fish and game preserve, health resort and pleasure ground for the benefit and enjoyment of the Province', it was actually to save this 1,466- (now nearly 3,000-) square-mile tract of lake and forest from the encroachments of homesteading settlers (rather than from the depredations of the mining and lumbering companies) that the Algonquin Park Act was passed by the Legislative Assembly of Ontario in 1893. Resource-extraction, including the removal of all the first-growth white and red pine, was allowed to continue after this date – facts recorded by Tom Thomson in his many oil sketches of logging activities, facilities and equipment, and amply evident in contemporary photographs – the chief industries of the Park were to be recreation and tourism.

Thomson's reversion to the canoe to make his acquaintance with the lakes and rivers of Algonquin, and by which he met his death in 1917, can be seen as a kind of throwback to an earlier mode of transit. For by 1912 this Indian invention was fast passing from the hands of the wilderness worker into those of the woodland vacationer and the Boy Scout camper. The

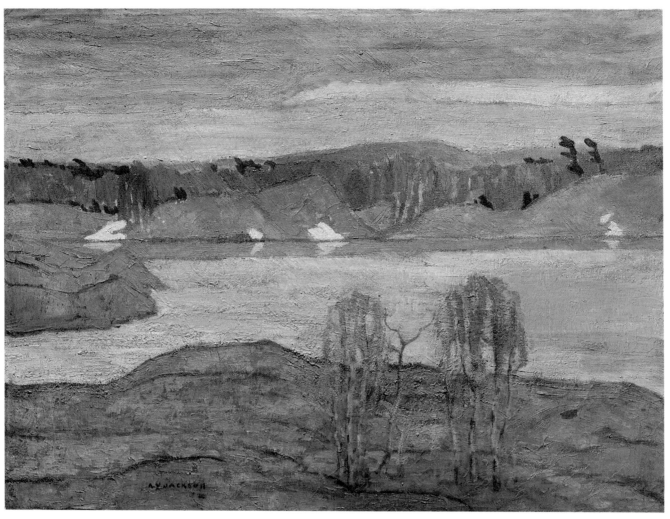

Alexander Young (A.Y.) Jackson, *Lake Cognaschene,* 1920
Art Gallery of Windsor Collection (cat.54)

terrain that Thomson and his companions took for their special province had already been staked out and divided up by a variety of commercial enterprises and transport companies. In 1885 the Grand Trunk Pacific line from Toronto reached the lumber town of Huntsville, just outside the present south-west corner of the Park, the eastern side of which was opened up to vacationers from the national capital when lumbering interests underwrote the construction of the Ottawa, Arnprior and Parry Sound Railway in 1896. By 1905 the Temiskaming and Northern Ontario (now Ontario Northland) Railway had put down steel as far north as New Liskeard, thus giving access to the beautiful Temagami region. The Canadian Northern Ontario Railway line from Toronto to Nickel Centre, east of Sudbury, was able to provide dropping-off points for trippers on the Moon, Magnetawan, Key, Pickerel and French Rivers by 1908. By 1913 the northern half of Ontario was connected by rail from east to west.

As early as the 1850s the advent of the steamship age had brought the tourist trade – and with it such landscape

ROBERT STACEY

C.W. Jefferys, cover of brochure published by the
Temiskaming and Northern Ontario Railway, c. 1910

Map showing extent of railway development in northern Ontario
as of 1922, in *Northern Ontario*, brochure published by the Legislative
Assembly of Ontario, Toronto, 1922

painters as William Armstrong, Daniel Wilson, W. N. Cresswell, Frances M. Hopkins and Otto Jacobi – to the upper Great
Lakes ports. The laying of railway branch-lines and spurs from these burgeoning coastal towns to serve the mines, lumber
camps, sawmills and power dams in the hinterlands allowed later travellers to exchange the comforts of the lake-boat
cabin, Pullman coach and specially commissioned boxcar for the primitive efficiency of the cedar-strip canoe.

In making use of this extended transportation network, the era's wilderness-seeking artists were both emulating
and abjuring their counterparts of the 1880s and 1890s, who had taken advantage of the Canadian Pacific Railways' offer of
free passes to landscape painters. This policy had allowed the likes of Lucius O'Brien, John A. Fraser, T. Mower Martin, F. M.
Bell-Smith, Marmaduke Matthews, William Brymner, G. Horne Russell, Robert Gagen, John Hammond, William Cruikshank,
and the photographers William M. Notman and Alexander Henderson, to roam the length and breadth of the new nation,
from the Atlantic to the Pacific. Commercially as well as artistically speaking, their most important destination was the
Rocky Mountains. The views these lofty peaks inspired could be of service to the Montreal-based sponsor in the
preparation of the CPR's publicity materials and in the decoration of its hotels and offices. However, as Dennis Reid has
noted, 'the great early public interest in images of the West continued to decline rapidly after 1888'.[17] By the late 1910s the
financially troubled transportation giants were no longer providing such *quid pro quo* service, and the arts councils of the
future were decades away, so that artists who wished to see their enormous country had to do so out of their own
pocketbooks, or with the assistance of that nearly extinct paragon, the enlightened patron.

The anti-academicians who looked to Tom Thomson and Lawren Harris for leadership financed their expeditions
not only with the help of such early supporters as the University of Toronto's Dr James MacCallum and the independently

J.E.H. MacDonald, *Canada and the Call, 1914,*
poster published by the Royal Canadian Academy, 1914

F.H. Varley, *Emigrants,* oil on canvas, 1912
(unfinished); possibly intended for reproduction on a travel or
immigration poster. Collection, The Thomson Gallery, Simpson's
of Canada, Toronto. Reproduced with permission of Thomson
Works of Art Ltd, Toronto

A.Y. Jackson, *Bon Echo Inn,*
poster published by Bon Echo Inn, 1924

Franklin Carmichael, *Playgrounds in Ontario,* cover of
brochure published by Canadian National Railways, 1934

wealthy Harris himself (a scion of the family which co-owned the Massey-Harris farm-implement manufacturing firm), but through their careers as graphic artists and designers. Although they missed out on the travel- and immigration-propaganda boom of the 1880s and 1890s, virtually all of these painters were employed by, or received freelance commissions from, studios and agencies which handled promotions for the major steamship and railway companies, and, during both world wars, from the federal and provincial governments.

The examples of applied artwork reproduced here testify to the high level of skill these illustrator-artists brought to such mundane if welcome chores. They also reveal the almost symbiotic relationship that subsisted between their work as decorative designers and their treatments, in studio canvases intended for exhibit and sale, of the same outdoor subjects that sometimes occupied their brushes, pens and Ben Day machines in the commercial art studios of Toronto. The Tom

A.J. Casson, *Help Finish the Job*, poster published by the National War Finance Board, Ottawa, 1941

Tom Thomson (attrib.), unfinished pen-and-ink design for calendar, c. 1912. Private Collection, Toronto

Thomson of an elegant ink drawing for a calendar is demonstrably the same artist whose gouache sketch for his 1915 oil, *Northern River* (National Gallery of Canada), could have served as the maquette for a railway travel poster. And yet, for all its *art nouveau* S-curves and opaque frontality, this cartoon is also a faithful rendering of the stream down which the artist had paddled in his lonely trek northward and westward to the French River in the spring of 1914. The sinuosities and primary hues of Lismer's large 1915 canvas, *Sumach and Maple, Huntsville*, likewise may betray a lingering reliance on past and imported conventions. But the impact that blazing autumn colours dancing against 'the ice-blue gleam of a pond half-seen through the interlaced branches' had on the awakening sensibilities of this recent fugitive from the grey industrial North is palpable. In no other pre-1920 picture is the *inevitability* of what the Group had to do, and in such large measure succeeded in doing, more manifest.

Tom Thomson, *Sketch for Northern River,* gouache on paper, 1912. Collection, Art Gallery of Ontario, Toronto

Arthur Lismer, *Sumach and Maple, Huntsville,* oil on canvas, 1915. Collection, The Thomson Gallery, Simpson's of Canada, Toronto. Reproduced with permission of Thomson Works of Art Ltd, Toronto

The 'poster-esque' style associated with Thomson and the Group was hardly an accident, nor was it dependent on a first-hand familiarity with European Post-Impressionism, Symbolism or Expressionism. Bold, mural-type outlines, stylized forms, emphatic drawing and flat, tapestry-like colour-patterns were, after all, tricks of the trade at the end of the age of the hand-cut colour separation and the dawn of the 'three-colour process'. Wyndham Lewis reversed the real order of events in his remark of 1946 that, 'when the hostility of the press and public held them up, "the Group" retreated into commercial design.' In fact, they began with commercial design, long before they had a press or a public from which to retreat. But Lewis is correct in stating that they always emerged again 'as – for the time and place – militant and iconoclastic. Their work was rude; they chopped out their paintings as if they were chopping wood. They adopted, often, the brutal methods of the bill-board artist to put their country across big and harsh and plain...'[18] We can still see the billboard in their landscapes and cityscapes, but no longer the 'emptiness and savagery' of their subject. Rather, we are appalled by its fragility and smallness, and at the same time enthralled by its enduring ability to salvage us from the ravages of modern civilization.

Like their predecessors, the Group employed practical means to achieve spiritual ends. In seeking out Nature's solitudes, they were enacting a ritual that thousands of their non-artistic contemporaries followed their lead in performing, but for which there were literary as well as pictorial precedents. As access to mid-Northern Ontario improved in the 1880s and 1890s, appeals for the creative appreciation of these increasingly threatened remotenesses had swelled into a kind of anthemic litany. In verse and prose the 'Confederation School' poet-critics Archibald Lampman, W. W. Campbell, Bliss

Carman, Charles G. D. Roberts and D. C. Scott had enjoined Canadian writers and painters to head to the 'cleanly' North, rather than to disport themselves in the jaded fleshpots of Europe. This challenge was eagerly taken up by the Toronto Art Students' League (1886-1904), which must be deemed the *fons et origo* of the Group of Seven and the movement it fostered.

C. W. Jefferys, an English-born painter-illustrator who joined the Toronto Art Students' League in 1888, recalled nearly fifty years later: 'We felt in the verse of Roberts, [Bliss] Carman, Lampman, Wilfred Campbell and Duncan Campbell Scott, interpretations of the Canada that was familiar to us and that we were trying to depict. Their work was a powerful and definite inspiration.'[19] In the same talk, Jefferys revealed that 'The New England writers, Hawthorne, Bryant, Emerson and Whittier, and especially Thoreau, confirmed and deepened our consciousness of a quality peculiar to North America that we felt was essential to its artistic expression, whether in words or in shapes and colours. We became Northern minded. Some of us were radical enough to revel in Walt Whitman.' The Transcendentalist Thoreau and Whitman, along with a handful of Theosophists, were to be the favourite author-mentors of the Group of Seven; J. E. H. MacDonald would go so far as to name his son, himself a gifted graphic artist and book designer, after the author of *Walden*.

Most League members utilized the Toronto Art Students' League's seasonal exhibitions and its annual illustrated calendar (published from 1893 to 1904) to air the results of their '*nulla dies sine linea*' credo and their regular sketch-outings. These took them from the farmlands and lakelands outside of Toronto to rural Quebec, and thence to the Rockies, the prairies, and the Pacific and Atlantic coasts; only the Arctic eluded their questing spirit. As Jefferys commented in 1935: 'During its existence this publication produced numerous excellent drawings, depicting the characteristic features of Canada, and the life of its people, past and present. It gave an opportunity for the early efforts of

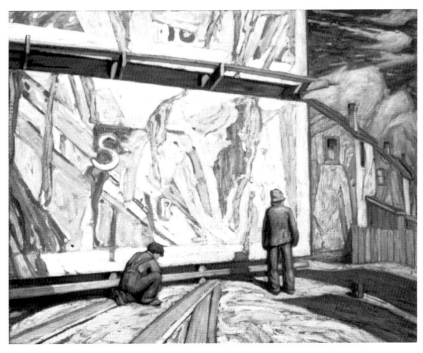

Lawren S. Harris, *Jazz*, oil on canvas, 1921.
Collection, Imperial Oil Ltd, Vancouver

C.W. Jefferys, *The Golden North* and *The Mines,* pen-and-ink, c. 1899. Reproduced in *1900: A Canadian Calendar for the Year with Notes and pictured things suggesting the impress of the Century on the land and its peoples,* designed by the Toronto Art League and published by George N. Morang, Toronto, 1899

several of the younger artists [in particular, J. E. H. MacDonald] who later have reached a wider audience, and it was of considerable influence in the development of public appreciation of native work.'[20] Two spreads from the 1900 edition of the calendar, by Jefferys himself and David F. Thomson, reveal why, for artists of this generation, the 'Golden North' would be as much the subject of elegaic longing for a paradise lost as the locus of nostalgia for a post-industrial future.

Reflecting at mid-century on this *fin-de-siècle* phenomenon, Jefferys proposed that 'In the purpose, and measurably in the performance of the Art League we can see the first indications of a native point of view in Canadian art…Today its principles, its ideals are the foundation of whatever is truly native in our painting and design. The stream of authentic Canadian Art can be traced back to that little spring that trickled forth in those days of fifty years or more ago.'[21]

Jefferys also wished to back-date two crucial influences on Canadian painters of this era, Impressionism and the modern Scandinavian school. The standard histories continue to insist that the impressionist palette and direct method of working were brought back to Canada from France by Clarence Gagnon in 1894, whereas in fact the first consistent Canadian practitioner of the mode was William Blair Bruce (1859-1906). Bruce had become a member of the Giverny circle in the 1880s, and was acquainted with the expatriate Scandinavian Impressionists through his Swedish sculptor-wife. Jefferys

ROBERT STACEY

David F. Thomson, *The Forest Primeval* and *The Saw Mill,* pen-and-ink, 1899. Reproduced in *1900: A Canadian Calendar for the Year with Notes and pictured things suggesting the impress of the Century on the land and its peoples,* designed by the Toronto Art League and published by George N. Morang, Toronto, 1899

himself could testify from personal experience that exposure to Impressionism did not require European travel and study, but merely called for open-minded awareness and a willingness to experiment:

'During the late 1880s a new influence began to affect us. We became aware of what seemed to be a daring and radical group: – the French Impressionists. Some of the Canadian art students who had been to Europe brought back with them the new methods of open-air painting in oil; touches of pure primary colour placed in juxtaposition, which viewed at the proper distance, gave a more brilliant representation of light and atmosphere. It was a seductive method, which seemed peculiarly adapted to the expression of the high-keyed luminosity and the sharp clear air of mid-Canada, though perhaps it was rather dangerous for the beginner who had not been trained to sound constructive draughtsmanship. But it helped to break down the undue emphasis on form, the rigidity of outline, and the microscopic detail of the English school, qualities which the student naturally exaggerated.'[22]

Yet Jefferys would have been the first to admit that the outdoor sketching ethos he espoused owed as much to the British landscape tradition of Constable, Crome and Cotman as to any newer model. At any rate, it was subject-matter and

geographical appropriateness, rather than niceties of style or technique, that most concerned his circle. As he explained:

'the first potent stimulus that we younger men experienced came in 1893. At the [World's] Columbian Exposition in Chicago were shown for the first time on this continent pictures by contemporary Scandinavian painters…Here we saw the work of artists dealing with themes and problems of the landscape of countries similar in topography, climate and atmosphere to our own: snow, pine trees, rocks, inland lakes, autumn colour, clear air, sharply defined forms. Carl Larssen, Bruno Liljefors, Fritz Thaulow were painting subjects that might have been found in Canada. Our eyes were opened. We realized that on all our painting, admirable as much of it was, lay the blight of misty Holland, mellow England, the veiled sunlight of France, countries where most of our painters were born or had been trained…'

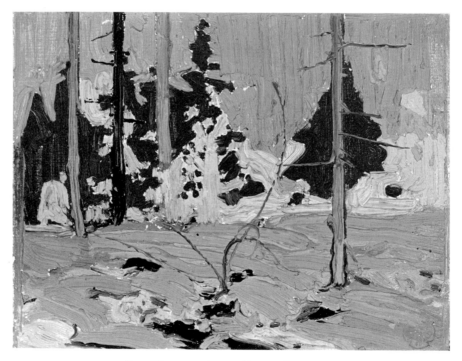

Tom Thomson, *Autumn, Algonquin Park,* undated
Agnes Etherington Art Centre, Queen's University, Kingston (cat.. 115)

To us younger painters these Scandinavian painters were a revelation. They encouraged us, they gave us confidence to tackle our problems without reference to the standards of other and quite different countries and to try to find an adequate way of expressing the character of our surroundings.[23]

The 'Scandinavian connection' was re-established when J. E. H. MacDonald and Lawren Harris travelled from Toronto to nearby Buffalo, New York to take in the *Exhibition of Contemporary Scandinavian Art* at the Albright Art Gallery in January 1913. This time, the 'revelation' was supplied by the likes of Prince Eugen, Otto Hesselbom, Gustav Fjaestad,

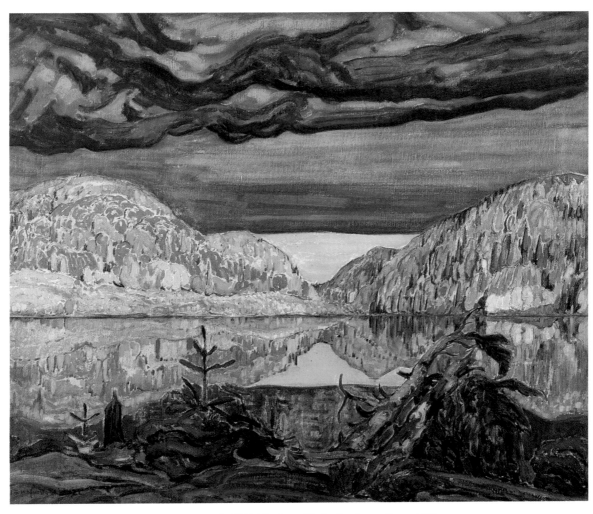

James E.H. (J.E.H.) MacDonald, *October Shower Gleam,* 1922
Hart House Permanent Collection, University of Toronto (cat.. 69)

Vilhelm Hammershoi, Harald Sohlberg and Edvard Munch, as well as by such older masters as Liljefors, Larssen and Zorn. Fondly recalling this *rencontre* some eighteen years later, in 1931, MacDonald retrospectively voiced his own glad cry of glad recognition:

> 'It seemed an art of the soil and woods and waters and rocks and sky, and the interiors of simple houses, not exactly a peasant art, but certainly one with its foundations broadly planted on the good red earth. It was not at all Parisian or fashionable. These artists seemed to be a lot of men not trying to *express themselves* so much as trying to express something that took hold of *themselves*. The painters began with *nature* rather than with *art*.'[24]

Here we have a response to the demands of revisionists who would know why MacDonald and Harris could not instead have exposed themselves of the Modernist work on view that same year at the epoch-making Armory Show in

New York. On the brink of converting to abstractionism, Lawren Harris in 1928 could appear to defend his former preference for the Scandinavian-Impressionist model in these words: 'We, who are true Canadians imbued with the North, are an upstart people with our traditions in the making…Art in Canada in so far as it is Canadian is an upstart art. Its source is not the same as the art of Europe…The Canadian artist serves the spirit of his land and people.'[25] A 'small and backward country' (as the Canadian-born Wyndham Lewis described the site of his exile in 1941) first requires a self to express before its artists can begin to express themselves. Such a self can be realized only after a people's artists have definitively answered Northrop Frye's famous query of 'Where is here?' Only when they have heeded the unnamed Iroquoian's reply to Cartier's 'Where am I?' – 'Ka-na-ta', meaning, in the vernacular, 'rest in my house' – will they learn to be at home in the global village that the world has become.

Although the Group of Seven was in rebellion against the constraints and falsities of both nineteenth-century Realism and Romanticism, it eventually came to be tarred with these two invidious brushes. The former charge, at least, is largely unfair, as George Woodcock affirms in his declaration that

'the main development in Canadian fiction [and, by implication, art] in fact bypasses the matter of realism, European or North American, largely because Canadians, faced with the wilderness on one side and a dangerously powerful neighbor on the other, had little doubt as to the actual nature of their predicament; what they needed was the combination of mythology and ideology that would enable them to emerge from mere escapism and present a countervision more real than actuality. Hence the weakness of realism as a tradition in literature or, for that matter, in the visual arts, where a national consciousness was first expressed through the highly colored and emphatically outlined formalism of the paintings of the Group of Seven and Emily Carr.'[26]

Nonetheless, diehard Modernists persist in taking pot-shots at the magnificent Seven, branding them traitors against their holy cause. Witness these recent grumblings by the Toronto abstractionist Ron Bloore:

'Now what were these people trying to do? This is interesting. The Group of Seven had a political agenda and that was to make Canadians love their country…No one has been able to do it…The Group of Seven had this political agenda of making Canadians recognize the soul of their country and the soul of the country is going to be the northland. Barren, just trees, fall or spring, that sort of thing, and just landscape going on and on and on, and no one in it. The French Canadians have never seen their soul in that way. But at Kleinburg [the site of the McMichael Canadian Art Collection, "that great Valhalla to the Group of Seven"]…the works were put together, collected by a rich man. And then other collectors of the Group of Seven could begin to donate works to Kleinburg with nice tax deductions, et cetera. So now school kids are brought in hideous yellow buses in droves to see, as it were, the soul of Canada. This landscape which is a late nineteenth, early twentieth century idea. I have to say late nineteenth and early twentieth century on the basis that they were working out of a European landscape tradition which was already defunct in Europe…It no longer had any viability.'[27]

I've quoted this diatribe at such length not only because of the exasperated sincerity of its expression but because of the number of common assumptions it betrays. Modernism of the severe, non-objective variety practised by Bloore has

never really captured the 'soul' of Canada; rather, a typically Canadian compromise has been sought between the concrete and the abstract, the near and the far, the Aristotelian and the Platonic. Nonetheless, the internationally oriented formalists who stormed the palace of Canadian culture in the 1950s and 1960s were harsh in their denunciations of the Group for its crime of communicating with a broad, secular audience. They decried the 'impurity' of the intentions of the nationalist campaign as much as its effects. For surely it is not the job of art to be anything more – or less – than art? Painting that seeks (as the foreword to the catalogue of the Group's first exhibition nakedly admitted) to 'interpret the spirit of a nation's growth' is painting with a set of agendas and premises more germane to those of political, immigration and tourism propaganda than with to disinterested placement of pigment on canvas or lines on paper.

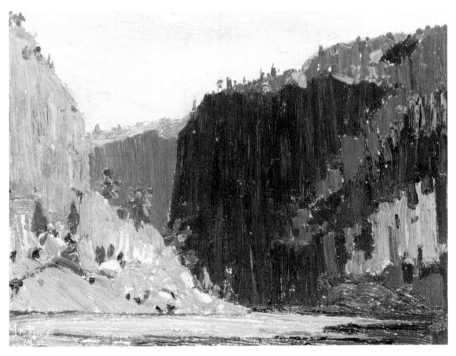

Tom Thomson, Petawawa Gorges, undated
McMichael Canadian Art Collection (cat.. 116)

Yet the promise and the problem of the Group of Seven did not go away when the new order took over. The myths remain, despite the best efforts of both the iconoclasts and the iconographers to remake or remove them. Could it be the legends attached to the Group contain the kernel of an indestructible truth: a truth that also inheres in the concrete abstraction that the Toronto-born pianist Glenn Gould proposed as 'The Idea of North'? Even today, for Canadians, geography is destiny, and destiny, geography.

Reflecting, late in his life, on 'the Character of Canadian Art, as affected by its environment', C. W. Jefferys inquired:

'Now, with traditions and training such as these [i.e. French and English], how is the painter to deal adequately with an environment such as ours? Where in his color-box can he find a tube of paint from which he can squeeze a

crimson, a scarlet, a burning orange that will flame like the autumn birch against a deep blue northern lake or the blaze of a maple against the pine forest? Where can he find a pigment that will fix upon canvas his response to the air and sunlight of a western wheat field?'[28]

Writing at about the same time, though now on the other side of the Atlantic, Wyndham Lewis offered an interested outsider's perspective in his review of Donald Buchanan's *Canadian Art*, published by Phaidon in 1945:

'Now it seems to me that for a person with these tastes, and with these traditions, Canada, artistically, offers extraordinary opportunities and that these have on the whole been surprisingly neglected. One would have expected for instance Canada to have produced one outstanding poet, inspired by the scene and by the history that is there as native as the folk-song 'Alouette'. This has not occurred.

But pictorially, in a sense, it has…This painting is, in fact, the blazing of a trail and a rough charting – a sometimes crude advertisement of a rich aesthetic vein – rather than a finished achievement of authentic beauty.'[29]

Though personally immune to 'the fly-blown joys of little Bush lakes', the Enemy had the generosity to concede that, despite Canada's divisions and susceptibility to external pressures, 'it has produced one thing that is as good in its field as anything on the North American continent, namely the Canadian school of painting.'[30]

Tom Thomson, *Fraser's Lodge (Mowat Lodge),* 1915
The Edmonton Art Gallery Collection (cat.. 110)

David Milne, *House and Clouds,* c. 1930-32
Collection of the Art Gallery of Nova Scotia (cat.. 84)

The achievement to which Lewis alluded remains unfinished; in some respects, it has hardly begun. Only in recent years have artists returned to the visual interpretation of that Canada which, in Lewis' words. 'will always be so infinitely bigger physically than the small nation that lives in it', and these have done so in defiance both of the masculinist solo heroism of the Group and of their preferred medium, oil painting. In so returning to the land, they are fulfilling Lewis's prediction that 'The pull of nature…will probably exceed that of the attraction exercised by the blast-furnace and the power house…The question in fact is whether all this unassimilable mass of "nature" will in the end be left severely alone…: or whether this proximity of the wilds will continue to influence the descendents of the contemporary Canadian. Surely the latter.'[31]

For these 'descendents', however, the North will never again be so inviolately wild, so instantly understood, or so ghostlessly haunted as it had seemed during the hegemony of the visionaries who re-blazed the trail into its heart. But the truth of the myth lives on, a religiously held fiction which transcends mere fact through the sheer necessity of its existence and utterance.

As long as the magnetism of the Shield country retains its hold on the collective imagination, the Group of Seven will be its popular embodiment. Proofs of this identification of the land with its delineators were finding their way into print as early as 1922, when, hymning 'the New Art', the 'Seranus' of my epigraph painted a vivid word-picture of a Group exhibition. Even today, few Canadians can read these awkward but evocative lines without experiencing the thrill of psycho-physical recognition which the Group of Seven sought to evoke in their cadmium and ochre odes to the True North:

'Dark shore', I said, Nay, for the colors clash
On the eye as modern music upon the ear.
The note, if loud, is true and strong, sincere.
The bluegreen trees are draped with many a sash
Of scarlet vines, and orange glamors flash
Through twisted garlands veiling a valley drear,
Where blasted trunks and wind-scarred summits rear

In that bleak Northland. Strong, if rash,
Those fluctuate ribs and webs of red and wine,
Those cold blue hills and skies evil black.
Birches faint ashen, lilac arms of pine
Bent crooked before the tempest's cruel track.
Last, as foil to such rich-tinted show,
Some fantasy of ice and crusted snow.[32]

NOTES

1. Robertson Davies, 'Party of One: The Northern Muse', *Holiday*, April 1964, repr. in *The Well-Tempered Critic: One Man's View of Theatre and Letters in Canada*, ed. J. S. Grant (Toronto: McClelland & Stewart, 1981), pp.236-37.

2. Margaret Atwood, 'Death by Landscape', *Harper's* 281, (August 1990), p.49.

3. J. E. H. MacDonald to F. B. Housser, 20 December 1926 (unsent). Photocopy in J. E. H. MacDonald Papers, Manuscript Division, National Archives of Canada, Ottawa.

4. C. Lewis Hind, 'Life and I', *The Daily Chronicle*, 30 April 1924; excerpted in *Press Comments on the Canadian Section of Fine Arts, British Empire Exhibition 1924-25* (Ottawa: National Gallery of Canada, 1925), p.9.

5. Sir John Douglas Sutherland Campbell, the Marquis of Lorne, 'The opening of an Art Institute of Montreal in 1879…', in *Memories of Canada and Scotland: Speeches and Verses* (London: Sampson Low, Marston, Searle & Rivington, 1894), p.220.

6. Lawren S. Harris, 'Revelation of art in Canada: a history', *The Canadian Theosophist* (1926), p.86.

7. Brian S. Osborne, 'The iconography of nationhood in Canadian art', *The Iconography of Landscape*, ed. Denis Cosgrove and Stephen Daniels (Cambridge: Cambridge University Press, 1988, repr. 1989), p.172.

8. Reid MacCallum, 'The Group of Seven: A Retrospect', in *Imagination and Design and Other Essays*, ed. William Blissett (Toronto: University of Toronto Press, 1953), p.163. Originally published in 1933.

9. P. G. Konody, 'The Palace of Arts at Wembley', *The Observer*, 24 May 1925; quoted in *Press Comments on the Canadian Section of Fine Arts…*, p.9.

10. F. B. Housser, *A Canadian Art Movement; The Story of the Group of Seven* (Toronto: The Macmillan Co. of Canada, 1926; repr. Toronto, 1974), p.162.

11. *Ibid.*, p.14.

12. Wyndham Lewis, 'Canadian Nature and its Painters', *The Listener*, 29 August 1946, repr. in *Wyndham Lewis on Art: Collected Writings 1913-1956*, ed. Walter Michel and C. J. Fox (London: Thames and Hudson, 1971), p.427. On the other hand, Lewis also contended that 'Nature' is 'still there' in Canada, and that 'Furthermore it is a damned good advertisement for the Canadians; and if they consulted their own interests — and were not so afraid as being treated as "hicks" — they would pretend they are much nearer to the Pole than in fact they are'. (Draft of a letter to Malcolm MacDonald, *c.* 1943, quoted in *The Letters of Wyndham Lewis*, ed. W. K. Rose (Norfolk, Conn.: New Directions,

1963), p.360, n.1.

13. *Ibid.*, p.163.

14. Audrey Saunders, *Algonquin Story* (Toronto: Ontario Department of Lands and Forests, 1963), p.14.

15. James Dickson, *Camping in the Muskoka Region: The Story of Algonquin Park* (Toronto, 1886; repr. Toronto: Ontario Department of Lands and Forests, 1960), p.9.

16. *Ibid.*, pp.15, 16.

17. Dennis Reid, *'Our Own Country Canada': Being an Account of the National Aspirations of the Principal Landscape Painters in Montreal and Toronto, 1860-1890* (Ottawa: National Gallery of Canada, 1979), p.437.

18. Wyndham Lewis, 'Canadian Nature and its Painters', p.427.

19. C. W. Jefferys, ['The Toronto Art Students' League]. Untitled, undated holograph MS of lecture (*c.* 1944?). C. W. Jefferys Estate Archive Papers. E. P. Taylor Reference Library, Art Gallery of Ontario, Toronto.

20. C. W. Jefferys, 'Canadian Art: Part I'. Undated holograph MS of two-part lecture delivered before an audience of teachers in the province of Quebec, 1935. Jefferys Estate Archive Papers, E. P. Taylor Reference Library, Art Gallery of Ontario, Toronto. It should be noted that Jefferys's reference to 'native art' is not to the Amerindian art to which the adjective 'Native' is now applied, but rather to art produced in Canada by resident Canadians.

21. Jefferys ['The Toronto Art Students' League].

22. *Ibid.*

23. *Ibid.*

24. J. E. H. MacDonald, 'Scandinavian Art'. Lecture given at the Art Gallery of Toronto, 17 April 1931; first published in *Northward Journal*, 18/19 (1980), pp.9-10. For a further discussion of this subject, see Robert Stacey, 'A Contact in Context: The Influence of Scandinavian Landscape Painting on Canadian Artists Before and After 1913', *Northward Journal* 18/19 (1980), pp.36-56; and Roald Nasgaard, *The Mystic North: Symbolist Landscape Painting in Northern Europe and North America, 1890-1940* (Toronto: Art Gallery of Ontario, 1984).

25. Lawren Harris, 'Creative Art and Canada', in *Yearbook of the Arts in Canada*, ed. Bertram Brooker (Toronto: MacMillan of Canada, 1929), p.184.

26. George Woodcock, 'Possessing the Land', in *The Canadian Imagination: Dimensions of a Literary Culture*, ed. David Staines (Cambridge, Mass.: Harvard University Press, 1977), pp.72-73.

27. Ron Bloore, in conversation with Eugene Knapik, 'The Ron Bloore Interview', *Work Seen*, 7 (December 1990-January 1991), p.22.

28. C. W. Jefferys, 'Notes on the Character of Canadian Art, as affected by its environment'. Undated holograph MS in 'Miscellaneous Notes', C. W. Jefferys Estate Archive Papers, E. P. Taylor Reference Library, Art Gallery of Ontario, Toronto.

29. Wyndham Lewis, 'Canadian Nature and its Painters' p.427.

30. Wyndham Lewis to Lorne Pierce, 26 May 1941. Lorne Pierce Papers, Queen's University Archives, Queen's University, Kingston, Ontario. This was prompted by receipt of a copy of Pierce's *The Armoury in our Halls*, a pamphlet lauding not only the landscape paintings of the Group of Seven but the nation-building historical art of C. W. Jefferys and Thoreau MacDonald.

31. Lewis, 'Canadian Nature and its Painters', pp.425-26.

32. 'Seranus' (S. Frances Harrison), 'To the New Art', *Verse and Reverse: By Members of The Toronto Women's Press Club* (Toronto: F. D. Goodchild, Ltd., 1922), p.45.

Alexander Young (A.Y.) Jackson, *Terre Sauvage,* 1913

National Gallery of Canada, Ottawa (cat. 48)

CHARLES C. HILL

THE NATIONAL GALLERY, A NATIONAL ART, CRITICAL JUDGEMENT AND THE STATE

'National Art Show Abuses Protested', 'Artists Boycott National Gallery Until Radical Reform Takes Place', '118 Artists Boycott Gallery In War to Oust Modernists' screamed newspaper headlines across Canada in December 1932 trumpeting the final stages of a conflict that had raged between artistic factions and the National Gallery of Canada for over ten years. Two petitions signed by 113 Canadian artists, including the current President of the Royal Canadian Academy and three past Presidents, were forwarded to the Prime Minister, accusing the Gallery of 'flagrant partisanship in selecting and hanging pictures at the Annual Exhibition held in Ottawa', and of having 'selected and distributed works at home and abroad that do not represent the best in Canadian art.' Unless a radical reform in the management and policy of the National Gallery was instituted the signatories would boycott all Gallery exhibitions.[1]

The critics cited specific instances of partiality dating back to the selection of works for the Canadian exhibition at the British Empire Exhibition at Wembley in 1924. The Toronto *Telegram* denounced the 'peculiarly objectionable' and 'impudent intolerance' of the response from Lawren Harris, 'leader of the Group of Seven, a coterie of painters of so-called modernist tendencies'. And in the Vancouver *Sun* J. A. Radford pursued his ten year old battle against 'This hideous and unnatural modernism…the distorted daubs of seven wilful men', demanding that 'parliament…find out what is wrong and…correct the error'.[2]

The Gallery refuted the accusations but the most vociferous responses came from the artists themselves: 'For nearly ten years there has been no cessation of the carping criticism by academic painters of the National Gallery at Ottawa, the Group of Seven and the modern movement in Canada generally and [of] efforts…to prove that what recognition the modernist has received is due only to favoritism in Ottawa', wrote A. Y. Jackson of the Group of Seven. Fellow member Arthur Lismer asserted: 'A national institution exists for the public and not for artists. The fact that one or two artists have a few more pictures in the national collection than others may be a matter of merit…Agitators like Mr Radford make it out to be a species of demeaning graft.' The noted print maker, W. J. Phillips of Winnipeg, wearily commented: 'The quarrel is a chronic one…What I want to see is peace and mutual help'. And from the small town of Palgrave, Ontario, the reclusive painter David Milne clearly identified the main thrust of the attack: 'It is, in effect, an attempt by the leaders of the R.C.A. [Royal Canadian Academy] to bring pressure to bear on the National Gallery and dominate its selections of works of art for exhibition or purchase by the nation. If the R.C.A. represented Canadian art as a whole and were responsible to the people of Canada, the movement would make some appeal to reason. However,…the Academy is

not either responsible nor representative. Neither the government nor any individual outside its own membership has any control over either its policies or its membership.'[3]

The Academy perceived itself to be the official representative of the visual arts in Canada and sought to regain control of its child, the National Gallery of Canada, that had abandoned its parent to promote the modernist credo expressed by the Group of Seven. In doing so, the National Gallery played a crucial part in creating a public role for modern painting in Canada. This study focuses the issue of how a nation state supported contemporary art.

Founded in 1880, the prime purpose of the Canadian Academy was to unite the artists in a Dominion institution for 'the encouragement of Design as applied to Painting, Sculpture, Architecture, Engraving and the Industrial Arts, and the promotion and support of Education leading to the production of beautiful and excellent work in manufactures; to be attained by:...The institution of a National Gallery at the Seat of Government....The holding of exhibitions in the principal cities of the Dominion....The establishment of Schools of Art and Design.'

The constitution of the Academy was based on that of the Royal Academy and on being appointed or subsequently elected to the status of full academician each member was required to submit 'a...specimen of his abilities in the walk of Art which he professes' to be deposited 'in the National Art Gallery at Ottawa (to remain there).'[4] In fact no such Gallery existed and it was through the foundation of the Academy and the deposit of the diploma works that a collection was created that constituted the sole manifestation of such an institution.

The separate Provincial governments across Canada jealously guarded their control of education, so that any efforts towards the foundation of a Dominion art school were inevitably doomed to frustration. Most of the energy of the Academy therefore went into the organization of the annual exhibitions selected by the academicians to represent the highest levels of artistic production in Canada. The exhibition rotated between Montreal, Toronto and Ottawa, alternating with the annual exhibitions organized by the local organizations in the larger two cities and bringing itself to the attention of the government when in Ottawa. In fact the Academy was somewhat a wandering orphan, surviving through the will of its membership and small subsidies from the federal government. Any efforts to establish an Academy headquarters or building were frustrated by the jealousies of the membership in the other cities so, *faute de mieux*, the National Gallery was perceived as the Academy's gallery, the repository by law of its collection of diploma works.

The government placed the diploma works under the care of the office of the Dominion Chief Architect, but it was only in 1882 that space was provided for their permanent display. In spite of an upgrading in its facilities in 1888 the Gallery was sorely neglected by the government. The Academy maintained a parental concern for its welfare, continuing to deposit the diploma works and purchasing works on occasion from the annual exhibitions for donation to the Gallery.

As the sole national organization of professional artists, the Academy sought the best means to further Canadian art and appealed to the state for assistance in its efforts. In 1903 a proposal was submitted which, among other issues, called for the formation of an advisory committee, composed of members of the Academy, for the 'expenditure of public money in matters connected with the fine arts', including annual purchases from the Academy's exhibitions, the construction of a proper gallery in Ottawa, establishment of scholarships for art students and financial assistance for the Academy to organize a representative exhibition of contemporary Canadian art for the 1904 Louisiana Purchase Exposition in Saint Louis (the Academy having organized such exhibits for the expositions at Chicago in 1893 and Buffalo in 1901).

Concerned by the neglected affairs of the National Gallery, the lack of authority of the custodians for the maintenance of the collection and the dispersal of the collections in parliamentary offices, the Academy President, George

Reid, submitted a new memorial to the Prime Minister in January 1907 calling for 'The establishment of a section in connection with the Department of Public Works to deal with all matters connected with the Fine Arts; that the head of this section should be the custodian of the National Gallery of Art and its collection; that there should be an advisory Council of the Fine Arts *composed of painters, sculptors and architects, such Council to be appointed by the Royal Canadian Academy*' and that all public commissions be entrusted to Canadian artists and that there be an annual allotment of funds for the Fine Arts. With unusual promptness the government responded and on 18 April 1907 an Order in Council was passed appointing an Advisory Arts Concil to '*be composed of gentlemen who have shown their interest in and appreciation and*

Charles Comfort, *Tadoussac,* 1935
National Gallery of Canada, Ottawa (cat. 18)

understanding of art as evidenced by their public connection with art associations and their private patronage of art', the three men being the wealthy Montreal collector Sir George Drummond, President, the Honourable Arthur Boyer, also of Montreal, and Byron E. Walker of Toronto. The Advisory Arts Council was mandated among other responsibilities, 'to cooperate and advise the Minister of Public Works in the selection and purchase of works of art for the National Art Gallery, Ottawa'.[5] While the Academy had attained the essentials of their appeal, there was resentment at the assumption of control by others than artists. But, as the Montreal painter and Academy President William Brymner explained to a fellow artist: 'It seems to me you do not understand the importance of having got an Advisory Art Council appointed. Before its appointment any hard up member of Parliament or friend of the Government had only to get hold of a minister or MP with sufficient influence and he could unload any rotten pictures he had on the National Gallery & Parliament Buildings, whereas now buying is done by non-political men who happen, at present anyway, to be above corruption.'[6]

Sir Edmund Walker, appointed President of the Advisory Arts Council in 1910, was probably the most remarkable

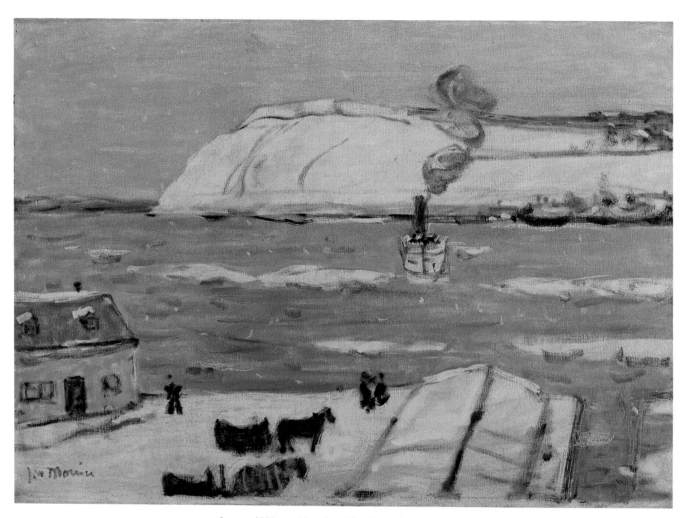

James Wilson Morrice, *The Ferry, Québec,* c. 1906
National Gallery of Canada, Ottawa (cat. 92)

Canadian of his generation. As general manager from 1886 and President of the Canadian Bank of Commerce from 1907, he was extremely influential in the banking world, stressing always the responsibility of the banks to society and to the country generally. His broad interests ranged from palaeontology to music, history and art, laying great emphasis on the importance of education for the development of the nation. To that end he was instrumental in the foundation and operation of, among numerous other organizations, the Toronto Guild of Civic Art (1897, a municipal arts advisory board for Toronto which was the model for the federal Advisory Arts Council), the Art Museum of Toronto (1900), and the Royal Ontario Museum (1912).

Sir Edmund Walker's tastes in art were characteristic of his generation, broad though conservative. He collected European, Canadian and Japanese prints and among the earlier artists he favoured the Italian 'primitives', Rembrandt and Velasquez, and the Barbizon artists. Among more modern painters he admired the Hague School, Macaulay Stevenson, John Lavery and John Sargent, the Spaniards Ignacio Zuloaga and Joaquin Sorolla, the Scandinavians Anders Zorn and Fritz

CHARLES C. HILL

David Milne, *Ollie Matson's House in Snow,* c. 1932
National Gallery of Canada, Ottawa (cat. 82)

Thaulow, and the more decorative work of Charles Ricketts and Charles Shannon. His preferences among Canadian artists closely paralleled the work of these artists.[7]

As Brymner affirmed, the formation of the Advisory Arts Council was of utmost importance for Canada, not only for putting the National Gallery on a sound basis, but for the first time the Canadian Government allocated an annual sum for purchases. Artists had been bemoaning for years the colonial preference of Canadian collectors for foreign art and the nefarious results this had on Canadian production. At one of the Advisory Arts Council's first meetings a notice was sent to Canadian organizations announcing their intention to buy Canadian art, recognizing that such an influx of funds into the market would have a positive effect on artistic ambitions and encourage Canadian artists residing abroad to send works for exhibition in Canada. The Council members visited the annual exhibitions in Montreal and Toronto, and consciously sought

to establish a national collection representative of all phases of Canadian art.[8]

With a rapidly expanding collection and plans for the move of the collection into the newly constructed Victoria Memorial Museum, Sir Edmund needed a knowledgeable curator and he selected a young Englishman recently arrived in Canada. Eric Brown, brother of the painter Arnesby Brown, was born in Nottingham and had studied art in England. He first came to Montreal in 1909 and then worked for the Art Museum of Toronto, where he met Sir Edmund who encouraged him to take up the Ottawa post.[9]

Eric Brown had a wide knowledge of art and a real sympathy with artists. In his early articles written for the *Christian Science Monitor* in Boston and for other Canadian, American and British newspapers and periodicals he stressed the necessity of art for national development, arguing from the point of view of both ancient and modern history. His tastes in contemporary art were similar to those of Sir Edmund, with the same limitations, rejecting the 'extremes' of 'futurism', and even balking at the 'incomprehensibility' of certain Van Goghs and the 'flaming colour and bestiality' of Gauguin.[10]

Eric Brown arrived in Ottawa in September 1910 and was soon occupied with plans for the move of the collections, preparing a new catalogue and making contacts with artists to document the works. Shortly after his arrival he discovered to his amazement that there was no legislative basis for the existence of the National Gallery and he set out to rectify the issue, drafting new legislation. The Advisory Arts Council members would now form the Gallery's Board of Trustees. At the same time the Royal Canadian Academy revised its legislative charter to include a clause which implied some measure of control over the National Gallery, 'instituted by the Academy in pursuance of its charter powers'. Recognizing the impossibility of control of a public institution by one, private, artists group, Sir Edmund obtained a modification of the offending clause, resulting in some rancour from academicians who resented the transfer of the Gallery to a lay, non-artist body.[11] However, the separation of the two organizations permitted the Trustees to take an independent stance for the furtherance of art in Canada.

To assuage the Academy, the Gallery's Board supported its application for an increased federal grant, instituted a scholarship to be paid for by the Gallery but administered by the Academy, and allocated more funds for the purchase of Canadian art from the exhibitions of the Academy and other societies. The increased number of works would permit the distribution of loan collections, following the system operative in France, to art organizations across the country. This would encourage the development of such groups, and bring the work of Canadian artists to the attention of a much larger public, thus encouraging further sales. Instituted in 1913 this programme would see thousands of works of art shipped across the country over the next two decades.[12]

The National Gallery's collections policy now became the focus of attention and was protested by Homer Watson, one of the charter Associates of the Academy, who insisted that 'the purpose of a national Canadian gallery is first of all to collect the worthy of our own Canadian art.'[13] This criticism was made in response to Sir Edmund Walker's statement at the recent Academy annual dinner that the Gallery Board intended 'to purchase one example of each school of painting from Egyptian times up to the present'. Rather boldly stated, the policy was better articulated by Eric Brown:

'There is no doubt that Canada has growing along with her material prosperity a strong and virile art which only needs to be fostered and encouraged in order to become a great factor in her growth as a nation. No country can be a great nation until it has a great art. I would like, however, since there seems to be some doubt about the matter, to make clear that the encouragement of our national art in its broadest and best sense is not achieved by the exclusive purchase of Canadian works of art. The purpose of our National Art Gallery is mainly educative, and

as a knowledge and understanding of art is only to be gained by the comparison of one work of art with another, so for this comparison to lead always to higher ideals and understanding we needs must have in addition to our own Canadian pictures the best examples we can afford of the world's artistic achievements by which we may judge the merit and progress of our own efforts. It is on these lines that the purchase of works of art for the National Gallery is proceeding.'[14]

The younger artists in the Ontario Society of Artists in Toronto, Lawren Harris and J. E. H. MacDonald, also objected, proposing a revision of the mandate of the 'Federal Art Commission', and A. Y. Jackson wrote from Montreal: 'That the hon. gentlemen of the Advisory Council…will end up with an assortment of good examples of unknown artists and a lot of bad examples of well known ones seems evident and we will have a museum like most museums neither better nor worse', and called on Ottawa 'to help us along and light up the way…against Dutch pot boilers and fake Barbizon masterpieces'.[15]

Lawren Harris made a further protest in the Toronto *Globe* castigating the expenditure of funds on foreign art. To the Gallery's announcement of the arrangements with the Academy, Harris again retorted that the money would be better spent on purchases determined by the art societies alone, that the Gallery should be a leader bringing into Canada the exhibitions of Scandinavian art and of the work of Sorolla and Zuloaga (then travelling in the United States), 'but instead of studying what we lack they merely add to what we are overwhelmed with. Their whole policy is a stupid and senseless effort to keep us on the beaten track which, so far as the artist is concerned, leads to oblivion. This is where Canadian art is bound unless it cuts itself loose from Barbizon and Holland and the Royal Academy in England and becomes something more than a mere echo of the art of other countries.'[16]

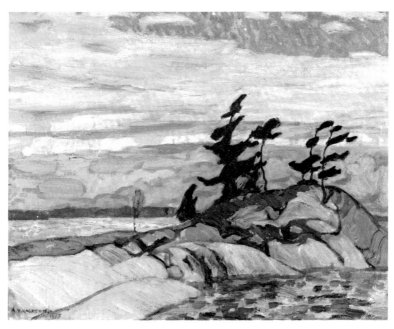

Alexander Young (A.Y.) Jackson, *Night, Georgian Bay,* 1913
National Gallery of Canada, Ottawa (cat. 47)

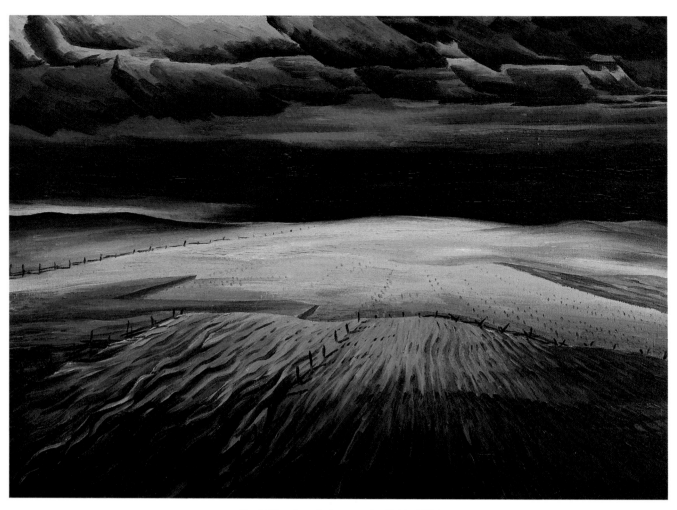

Carl Shaefer, *Storm over the Fields,* 1937
Collection Art Gallery of Ontario, Toronto (cat. 104)

In fact the Gallery had already purchased paintings by the younger Toronto artists including J. E. H. MacDonald, Arthur Lismer, A. Y. Jackson, Tom Thomson and Lawren Harris himself. Walker and Brown were keenly aware of and supported the new directions Canadian art was taking as Brown wrote in 1913: 'A national spirit is being slowly born… There are painters who are finding expression of their thought in the vast prairies of the far West, in the silent spaces of the North, by the side of torrent and tarn, and in the mighty solitudes of the winter woods.'[17] However, this new movement was not confined solely to the above artists who now occupied the recently constructed Studio Building in Toronto, and who were perceived by Brown and Walker to be developing talents to be watched. On the other hand these artists were seeking allies and were trying to win over the Gallery's Trustees and Director as partners in the struggle for recognition of their vision of Canadian art.[18]

In this they were clearly successful, and in the Gallery's annual report for 1914-15, in which further purchases of paintings by MacDonald, Harris and Jackson were reported, Brown wrote: 'It is interesting to record at this time that

CHARLES C. HILL

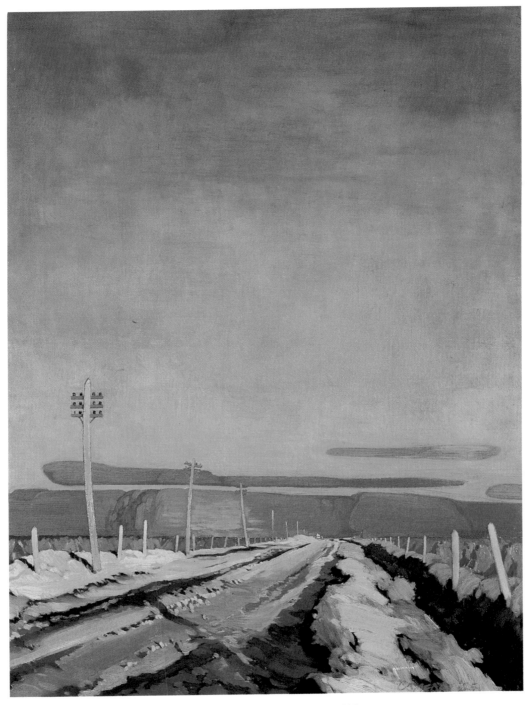

Charles Comfort, *Prairie Road,* 1925

Hart House Permanent Collection, University of Toronto (cat. 17)

First National Gallery of Canada loan exhibition at the St.John Art Club,
St. John, New Brunswick, 1913. These exhibitions distributed the national collections
across Canada to encourage interest in Canadian art.

Canadian art is undergoing a great change and a greater growth. The earlier Canadian artists who were trained entirely in Europe, and who were encouraged by Canadians when they were encouraged at all, to paint European pictures or at best to see Canada through European eyes, are passing. A younger generation is coming to the fore, trained partly in Canada, believing in and understanding Canada and, to some small though quite insufficient extent, encouraged by Canadians. These artists are painting their own country and realizing its own splendours and its character with an outburst of colour and enthusiasm which bids fair to carry all before it. The exhibitions of this past year have illustrated this movement more widely than ever before, and many are convinced that they are looking into the dawn of a new art era in Canada which will glorify their country and help its people towards a better understanding of one of the greatest refining influences in the national life.'

This same message was repeated for a larger audience in *The Studio* where the Toronto group was cited as the most significant movement in Canadian art today, and to his British audience Brown wrote:

'Canada has at least two seasons incomparable the world over, her autumn and her winter, and it is the fiery glory of the one and the white grandeur of the other, which are inspiring her painters to the sincerity of purpose and simplicity of method. It may seem almost unbelievable to people in England that, within an hour or two's railway journey from Ottawa and almost within sight of it, lies a thinly inhabited land where the lakes teem with fish and the woods with wild animals, where in the autumn the scarlet maples blaze among the dark pines, and in the winter wolves tear down the deer. This is the land the painters are seeking, and it must inspire great thoughts and great work.'[19]

Walker and Brown, determined to aid in the development of Canadian art, found in the Toronto artists kindred spirits who were not only strong painters but articulate and aggressive spokesmen. Their painting was also modern but not

CHARLES C. HILL

radical. Lecturing in western Canada in 1921 Brown went out of his way to assert that 'We must not confound this modern tendency…with futurism. Any movement tending to distort art and art's creations has as much relation to true art as Bolshevism has to true government and candidly it is a sign of degeneracy'.[20] In 1913 when the work of John Lyman, a pupil of Matisse, was exhibited and denounced in Montreal (the journalistic debate being stimulated by the Armory Show controversy in New York), Brown and Walker remained silent. But in the Toronto artists they found an art that conformed to the modern schools that interested them abroad, a national school like that of Scandinavia.

With the outbreak of war in September 1914 there was a severe dislocation of the economy which had a disastrous effect on artists who saw employment opportunities in the graphic and commercial arts practically disappear. Purchases by the Gallery became all the more important for all artists and they continued until 1917, when the operating budget was slashed. The destruction of the Parliament Buildings by fire in February 1916 and the occupation of the Victoria Memorial Museum by Parliament required a change of focus in the Gallery's activities. The loan programme of past and recent acquisitions was expanded to include art organizations, public libraries and agricultural fairs across the country and for the first time the Gallery took upon itself the organization of an exhibition of Canadian art to be shown outside Canada. This was the first major show since the Canadian Academy's exhibition in Liverpool in 1910, and toured in the mid-western States in 1918-19. The exhibition included a strong representation of the modern Toronto artists now known as the Algonquin Park School.[21]

In a further effort to assist Canadian artists, Sir Edmund Walker coordinated the selection and operations of the Canadian artists employed to document the military activities of Canadians in Europe as well as the war effort on the home front under the Canadian War Records programme initiated by Lord Beaverbrook in London. The artists selected for both projects included a broad range of both conservative and modern painters and sculptors. The pictures produced under these programmes were delivered into the custody of the National Gallery at the end of the war and their proper housing became an important argument for a new Gallery building as the Gallery prepared its move back into the Victoria Memorial Museum where it reopened in expanded facilities in September 1921.[22]

The end of the war saw renewed activity on all fronts. The Academy proposed another revision of its charter and requested a greatly increased grant from the government wanting to ally itself under the same ministry as the Gallery to enable it to organize exhibitions for circulation across the country and abroad.[23] The Toronto artists formed themselves into a formal alliance known as the Group of Seven holding their first exhibition in May 1920 and immediately sent off exhibitions to smaller centres in Ontario and Western Canada and to the United States.[24] With an increased budget the National Gallery was able to make purchases once again from the annual society exhibitions. While maintaining a broad policy, a real commitment was made to purchase the work of the younger, modern artists, including the Group of Seven. During the summer of 1921 Eric Brown lectured across western Canada on 'Canadian Art and the Canadian National Gallery', promoting the National Gallery's loan exhibitions and the work of the 'school of native Canadian painters', and encouraging local communities to organize their own galleries and art schools. Each, he argued, was a factor working to raise the standards of art, to assist contemporary artists and to recognize art as an economic necessity for the development of design and commerce.[25]

The Gallery's activities and acquisitions were being carefully watched on all fronts. As A. Y. Jackson wrote: 'The 7 Group are not loved very much by their confreres, and it will only be a matter of time before opposition takes a definite form. The obvious way…will be for the two official art bodies [the Royal Canadian Academy and the Ontario Society of Artists] to control the government purchases, and use it as a club for all those who do not conform to academic standards…'[26]

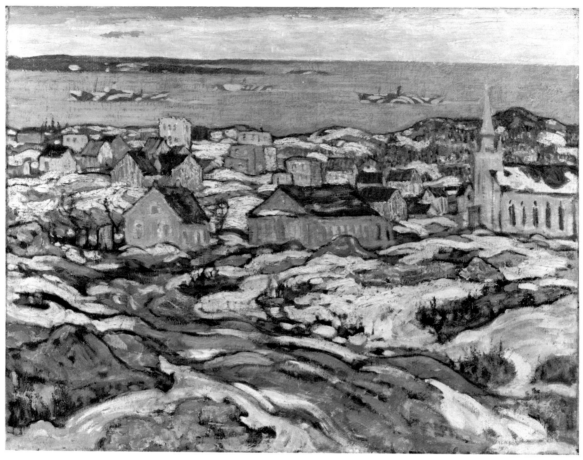

Alexander Young (A.Y.) Jackson, *Entrance to Halifax Harbour,* 1919
The Trustees of the Tate Gallery, London (cat. 52)

The definite form the opposition took was an article by Hector Charlesworth, a Toronto critic who had taken on the new modern art in his column before. Entitling his article, 'The National Gallery a National Reproach' he bitterly chastised the Trustees for their Canadian acquisitions, 'painters of an inferior quality over-represented; painters of a high quality in some instances unrepresented or represented by their second best…There are over thirty pictures by members of the Group of Seven, a Toronto body which adapts the methods of the theatrical scene painter to a smaller frame.' Sir Edmund Walker replied: 'It is rather a weakness in the force of his criticism of the Canadian modernists that it should be at such complete variance with the opinion of critics of the world wide reputation who have seen them. They seem to think, and have no hesitation in saying with the utmost publicity that the modern Canadian school is one of the most interesting developments of art in evidence for a long time, largely because it is something truly Canadian and does not depend for its style or form on any other country or convention…The loan exhibition work extending from the Atlantic to the Pacific has necessitated the purchase of very many Canadian pictures and from it has resulted a great growth of interest in art throughout the country. It has been the direct cause of the formation of art societies and art galleries and by its means it can

CHARLES C. HILL

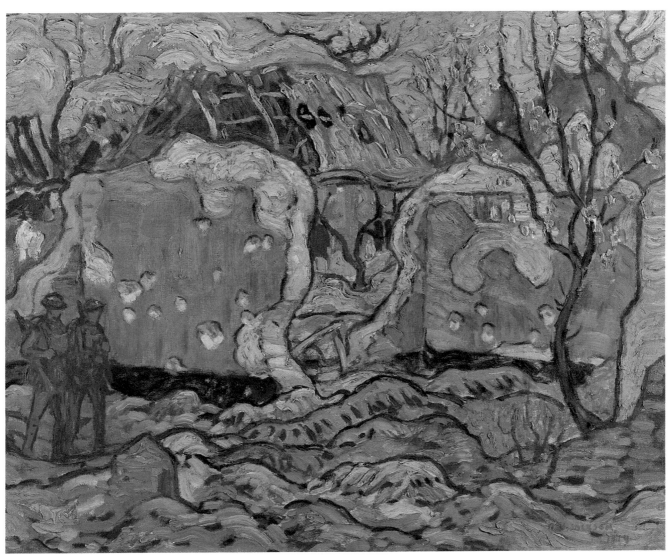

Alexander Young (A.Y) Jackson, *Springtime in Picardy,* 1919
Collection Art Gallery of Ontario, Toronto (cat. 51)

be fairly said that Canadian art has become known to Canadians.'[27]

Smarting from the Gallery's neglect of their work, the consistent propagandizing for the work of the 'modernists', and the assistance provided by the Gallery to the Group of Seven and associates in shipping their paintings for exhibition with the Gallery's loans, the senior academicians were looking for an opening to express their hostility. The occasion was offered by the Gallery's obtaining authority to organize for the government the Canadian art exhibition at the British Empire Exhibition at Wembley in 1924. G. Horne Russell, the Academy's President, protested that the Gallery was usurping the prerogative of the national artists body in organizing this show. He and several other artists threatened to boycott the exhibition unless control was handed over to the Academy.[28] The battle was waged in the press for years.

CHARLES C. HILL

With astute political judgement, a jury to select art for Wembley was appointed by the Board of Trustees composed of both conservatives and moderns, all members of the Academy. The success of the resultant exhibition and the positive critical response to the work of the Group of Seven from the British and American press appeared to vindicate the actions of the Gallery which made sure they were reprinted in newspapers across Canada as well as being issued in a separate publication.[29] The Wembley pictures toured through Britain and a selection was invited for the International Exposition in Ghent in 1925. A second display of Canadian paintings was shown at Wembley under National Gallery auspices in 1925 and later in Paris in 1927.

Meanwhile, to deflect the repeated accusations by the conservative academicians of favoritism in the Gallery's acquisitions, it was decided that works of art, selected from the annual art exhibitions of the various art societies by the Trustees in the respective cities, would be brought to Ottawa for an all-Canadian annual exhibition and from this the purchases would be made with all the Trustees present. In 1928 this was modified so that the selection was made in conjunction with representatives of the organizing society, the head of the provincial society or head of the local art school.[30]

But in the eyes of the opposition the National Gallery and the Group of Seven were synonymous and equal targets for criticism. The opposition to the Group was articulated in its most crude form as 'This hideous and unnatural modernism…the distorted daubs of seven wilful men'. Homer Watson and George Reid, who had made important contributions to the growth of art in Canada, objected to the Group's pretention to define 'what is Canadian and what is not'. When Fred Housser's book *A Canadian Art Movement: The Story of the Group of Seven* was published in 1926, the Ottawa portrait painter Ernest Fosbery denounced the creation of a Group mythology: 'The Amateur Myth; the fable that the members of the group were amateurs "uncontaminated" by European influence…The Discovery Myth; the fable that they "discovered" that Canadian landscape was paintable…The National School of Painting Myth; the claim that these men

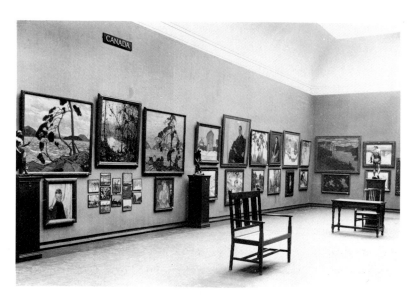

Exhibition of Canadian Art at the British Empire Exhibition, Wembley, 1924.
The work of Tom Thomson and the Group of Seven received special recognition
from the British Press vindicating the Gallery's support of their work in face of
opposition from the Royal Canadian Academicians

Exhibition of Canadian Art at the Provincial Exhibition, New Westminster,
B.C., 1928. The paintings were loaned by the National Gallery of Canada, the Group
of Seven and younger artists from Montréal. Private Collection.

are the first and only Canadian painters, in fact that a national school of painting has arrived.'[31] That the National Gallery, a state institution, would support this art through purchases and exhibitions roused the critics into paroxysms of fury.

If united in sentiment about the Gallery's active support of modern artists, the academicians (there were only forty) were divided as to the best tactics in how to deal with it; as a body the Academy never took an official stance in these matters. The focus of opposition came from the senior academicians and at their annual meeting in November 1926 they demanded 'the Head of [the] Art Dictator of Canada', Eric Brown.[32] In 1927 further accusations were made that the Gallery had bypassed the artists jury in selecting the paintings to be exhibited in Paris and the attacks became increasingly personal and acrimonious.[33] From the west coast John Radford led the fight against the Gallery and the Group of Seven, reviving accusations made in 1923 and again in 1925 that the Gallery discriminated against the West in charging them freight for loan exhibitions and that it manipulated the selection of works for the annual exhibitions of Canadian art held in Ottawa from 1926 to 1933.[34]

All this led Eric Brown to suggest in 1925 that the organizers of the New Westminster Provincial Exhibition in British Columbia contact the artists directly: 'I would rather we had nothing to do with anything Canadian for a year or two.' And from Paris in 1927 he expressed the wish that the French journalists wouldn't 'all write stuff that makes me personally responsible for everything done in Canada'.[35]

The Gallery tactically withdrew and turned over the selection of Canadian works requested for annual exhibitions at the Imperial Institute in London from 1927 to 1930 to the Academy but the major exhibitions of contemporary Canadian art shown in the United States from 1930 to 1932 were arranged without official Gallery participation. It was clear that the modern artists could stand on their own feet, though Brown continued to write about them, noting parenthetically, 'anywhere else in the artistic world this movement would be considered almost unduly conservative, and only at home, and because of its partial break with tradition, does it seem to some people to be at all radical'.[36]

David Milne, *Blue Sky, Palgrave*
National Gallery of Canada, Ottawa (cat. 91)

The catalyst for the final scenario seems to have been a combination of factors. Some of the wealthier academicians were severely hit by the stock market crash of 1929. The patrons of these artists also suffered financially and the portrait painters saw their clientele disappear. The forced resignation in 1932 of a member of the National Gallery Board, Newton McTavish who had, since his appointment in 1922, consistently supported some of the most severe of the Gallery's critics, was also undoubtedly a factor.[37]

Frustrated by their failure to make any headway with their protests, the artists hoped that a new Prime Minister (R. B. Bennett was elected in 1930) would support their appeals. Meetings with lawyers and politicians and correspondence continued for over two years but in the end the Prime Minister supported the Gallery's Board and rejected the complaints of the petitioners.

The academicians' campaign against the work of the Gallery's Board and Director had an unexpected result. The artists of the Group of Seven were in a quandary as to what direction they should take. Their exhibitions since 1928 had included invited contributors and the addition of Edwin Holgate of Montreal and Lemoine FitzGerald from Winnipeg to

Lionel LeMoine (L.L.) FitzGerald, *The Pool,* 1934
National Gallery of Canada, Ottawa (cat. 32)

David Milne, *Spring on Hiram's Farm,* 1932
Collection of the Winnipeg Art Gallery (cat. 85)

their Group sought to extend their range of influence. A petition in support of the National Gallery was signed by 282 Canadian artists from across the country. It was clear that there was a need for a national organization of modern artists to counter the repeated attacks. The Canadian Group of Painters was formed in the spring of 1933 and held their first exhibition that summer.

In the face of vicious opposition Sir Edmund Walker, Eric Brown and the Group of Seven maintained their commitment to the development of art in Canada. Through the purchase of the Group's paintings, the distribution and presentation of their work across the country and abroad, by lecturing and writing, the Gallery supported their creative, national vision. If at times their priorities and ideas as to how things should be done differed, working together they realized their goals. By the late 1930s there were art organizations in almost every town in Canada and galleries and art schools in most major cities. And most important there were Canadians looking at, supporting and buying Canadian art. There was certainly no unanimous national vision among Canadians, but the National Gallery and the Group of Seven and their supporters had played a vital role in the development of a Canadian consciousness.

NOTES

1. 'National Art Show Abuses Protested,' *The Sun* (Vancouver), 31 May 1932; 'Artists Boycott National Gallery Until Radical Reform Takes Place', *The Journal* (Ottawa), 8 Dec. 1932; '118 Artists Boycott Gallery In War to Oust Modernism', *The Mail & Empire* (Toronto), 9 Dec. 1932. F. H. Johnston, Toronto to Hon. R. B. Bennett, Ottawa, 25 Jan. 1932; A. Heming, Toronto to Hon. R. B. Bennett, Ottawa, 1 March 1932; H. Fabien, Ottawa to Hon. R. B. Bennett, Ottawa, 23 April 1932; T. W. Mitchell, Toronto to Hon. R. B. Bennett, Ottawa, 27 April 1932 and 18 Nov. 1932. Copies in National Gallery Archives (NGCA).

2. W. S. Maxwell, 'Canadian Artists Protest', *The Gazette* (Montreal), 13 Dec. 1932; E. Fosbery, 'The Artists Complaint', *The Journal* (Ottawa), 15 Dec. 1932; E. Fosbery, 'Artists at Odds', *The Globe* (Toronto), 23 Dec. 1932; 'Unearned Infallibility Yourself Mr Harris', *The Telegram* (Toronto), 16 Dec. 1932; J. A. Radford, 'Favoritism', *The Sun* (Vancouver), 20 Dec. 1932.

3. 'Denies Charge of Artists that Choice Unfair', *The Whig-Standard* (Kingston), 8 Dec. 1932; Eric Brown, 'The National Gallery and Its Opportunities', *The Whig-Standard* (Kingston), 15 Dec. 1932; A. Y.

Jackson, 'What's Wrong with the Academic Painter?', *The Mail & Empire* (Toronto), 14 Dec. 1932; A. Lismer, 'National Gallery and Artists', *The Mail & Empire* (Toronto), 30 Dec. 1932; W. J. Phillips, 'Art and Artists', *The Tribune* (Winnipeg), 24 Dec. 1932; D. Milne, '"The War": An Artist's View', *The Citizen* (Ottawa), 6 Jan. 1933.

4. *Constitution and Laws of the Canadian Academy of Arts* (Ottawa: A. Bureau, 1879).

5. See Ann Davis, 'The Wembley Controversy in Canadian Art', *Canadian Historical Review*, vol. LIV, no.1 (March 1973) pp.48-74 for a detailed description of the 1903 and 1907 proposals.

6. William Brymner to Edmund Morris, 25 April 1912, Edmund Morris Papers, E. P. Taylor Reference Library, Art Gallery of Ontario, Toronto.

7. *Jubilee of Sir Edmund Walker C.V.O., LL.D., D.C.L. 1868-1918* (Canadian Bank of Commerce, 1918); G. P. de T. Glazebrook, *Sir Edmund Walker* (Oxford University Press, 1933); K. Jordan, *Sir Edmund Walker Print Collector* (Toronto: Art Gallery of Ontario, 1974); D. Waterhouse, *Images of Eighteenth Century Japan Ukiyoe Prints from the Sir Edmund Walker Collection* (Toronto: Royal Ontario Museum, 1975); Byron Walker, 'Early Italian Painters', *The Week* (Toronto), 30 March, 6 April 1894; 'A Toronto Art-Lover's Picture Gallery', *Toronto Saturday Night*, 26 Feb. 1910; N. McTavish, 'Sir Edmund Walker's Collection of Art', *Canadian Magazine*, vol. LII, no.4 (Feb. 1919) pp.833-41. Sir Edmund Walker's papers and journals are in the Thomas Fisher Rare Book Library, University of Toronto. There are numerous references to art in his journals.

8. Advisory Arts Council (AAC) Minute Books, Meeting of 18 July 1907, NGCA. B. E. Walker, Toronto to Sir G. Drummond, Montreal, 6 Aug. 1907, Walker Papers, *loc. cit.* The Gallery's acquisitions and activities were reported in the annual report of the Department of Public Works from 1882 to 1920. The Gallery published its own reports from 1920.

9. F. Maud Brown, *Breaking Barriers Eric Brown and the National Gallery* (The Society for Art Publications, 1964); 'Curator of the National Gallery', *The Globe* (Toronto), 10 Sept. 1910; W. Brymner, Montreal to Edmund Morris, Toronto, 10 Dec. 1909, Edmund Morris Papers, E. P. Taylor Reference Library, Art Gallery of Ontario, Toronto; Eric Brown, 'British Painting in Montreal', *Canadian Courier*, 18 Dec. 1909; AAC Minute Books, Meeting of 11 June 1910, NGCA; Eric Brown, Toronto to Byron Walker, Toronto, 25 June 1910, Walker Papers, *loc. cit.*

10. Eric Brown, 'The Fruit of the Artistic Tree' (typescript, n.d. c. 1917-20); Eric Brown Papers, NGCA.

11. Eric Brown, Ottawa to Sir E. Walker, Toronto, 22 April 1911, NGCA; Sir E. Walker, Toronto to F. D. Monck, Ottawa, 19 Jan. 1912, Walker Papers, *loc. cit.*; E. Morris, Toronto to W. Brymner, Montreal, 12 April 1912 and W. Brymner, Montreal to E. Morris, Toronto, 25 April 1912, Edmund Morris Papers, *loc. cit.*; R. F. Fleming, 'Homer Watson Painter of Canadian Pictures', *The Journal* (Ottawa), 15 Nov. 1913. See also A. Davis, *op. cit.*

12. 'Memorandum of a Conference between Trustees of the National Gallery and Committee of the Royal Canadian Academy, November 22nd, 1913', NGCA; Sir E. Walker, Toronto to R. Rogers, Ottawa, 24 March 1914, Walker Papers, *loc. cit.*; *Royal Canadian Academy Report for 1913*, pp.10-13.

13. R. F. Fleming, 'Homer Watson, Painter of Canadian Pictures', *The Journal* (Ottawa), 15 Nov. 1913.

14. Eric Brown, 'The National Art Gallery of Canada', *The Globe* (Magazine Section) (Toronto), 4 May 1912; Eric Brown, 'The National Art Gallery of Canada at Ottawa', *The International Studio*, vol. XLIX (March 1913), pp.15-21.

15. Ontario Society of Artists Minute Book, Meeting of 4 March 1913, Ontario Archives, Toronto; A. Y. Jackson, Montreal to Eric Brown, Ottawa, 12 March 1913, NGCA.

16. 'Artists to Present Picture to Gallery', *The News* (Toronto), 8 Nov. 1913; L. S. Harris, Toronto to Eric Brown, Ottawa, 14 May 1914, NGCA; Cadmium [Lawren Harris], 'Canada's Artists and Foreign Art', *The Globe* (Toronto), 14 May 1914; 'National Gallery Will Encourage Art', *The Globe* (Toronto), 28 May 1914; L. Harris, 'The Federal Art Commission', *The Globe* (Toronto), 4 June 1914.

17. Eric Brown, 'Canada and her Art', *Canadian National Problems* (Philadelphia: American Academy of Political and Social Science, 1913), pp.171-76.

18. 'Model Studios Will Develop Natural Art', *The Star* (Toronto), 28 Feb. 1914; Gregory Clark, 'Why Canadian Art is Not Popular With Collectors', *The Star Weekly* (Toronto), 21 Nov. 1914.

19. Eric Brown, 'Studio-Talk – Ottawa', *The Studio*, vol. LXIV (April 1915), pp.205-12; Eric Brown, 'Landscape Art in Canada', *Art of the British Empire Overseas* (London: The Studio, 1917), pp.3-34.

20. 'Director Lauds Modern School', *Vancouver Daily World*, 21 June 1921.

21. Originally organized for the Festival of Empire in London but cancelled due to the death of King Edward VII, the Canadian Art Exhibition was shown at the Walker Art Gallery in Liverpool, 4-23 July 1910. Saint Louis, City Art Museum, *Exhibition of Paintings by Canadian Artists*, 8 Nov. 1918.

22. See Maria Tippett, *Art at the Service of War: Canada, Art and the Great War* (Toronto: University of Toronto Press, 1984).

23. E. Dyonnet, Montreal to the Secretary of State, Ottawa, 11 April 1921, and Petition of the Royal Canadian Academy of Arts to Governor-General Baron Byng of Vimy, 9 Sept. 1921, copies of both in NGCA. The Trustees of the Gallery opposed the petition.

24. A. Y. Jackson, Toronto to Eric Brown, 30 Nov. 1920, 18 Jan. 1921 and 24 April 1921, all in NGCA.

25. 'Art Mission of National Gallery', *The Gazette* (Montreal), 19 April 1921; 'Canada Has Pressing Need of Her Own Art', *Free Press* (Winnipeg), 11 June 1921; 'Modern Canadian Painting Equal to World's Best, Says Director of Art Gallery', *The Tribune* (Winnipeg), 11 June 1921; 'Director Lauds Modern School', *Daily World* (Vancouver), 21 June 1921;

'Art Acclaimed National Need', *The Sun* (Vancouver) 21 June 1921; 'Have Painters But Lack Appreciation', *Daily Colonist* (Victoria), 26 June 1921.

26. A. Y. Jackson, Toronto to Eric Brown, Ottawa, 24 April 1921, NGCA.

27. Hector Charlesworth, 'The National Gallery a National Reproach', *Saturday Night*, 9 Dec. 1922; 'Canada's National Gallery A Letter from Sir Edmund Walker and a Reply by Mr Charlesworth', *Saturday Night*, 23 Dec. 1922. Charlesworth stressed that his criticism was not of Eric Brown but of the Trustees. See also Hector Charlesworth, 'And Still They Come! Aftermath of a Recent Article on the National Gallery', *Saturday Night*, 30 Dec. 1922.

28. G. Horne Russell, 'Art at the British Empire Exhibition An Open Letter to Sir Edmund Walker', and Hector Charlesworth, 'Canada's Art at the Empire Fair', *Saturday Night*, 15 Sept. 1923; 'Sir Edmund Walker's Letters re the British Empire Exhibition', *Saturday Night*, 22 Sept. 1923; Homer Watson, 'Canadian Art at British Empire Exhibition', *Saturday Night*, 6 Oct. 1923; 'An Appeal to Painters', *Saturday Night*, 6 Oct. 1923; 'Canadian Pictures at Wembley Inadequate Character of the Display Proven by Documentary Evidence', *Saturday Night*, 31 May 1924. See also A. Davis, *op. cit.*

29. *Press Comments on the Canadian Section of Fine Arts British Empire Exhibition* 1924 (Ottawa: National Gallery of Canada, 1924) and *Press Comments on Canadian Section of Fine Arts British Empire Exhibition 1924-25* (Ottawa: National Gallery of Canada, 1925).

30. 'Memorandum on the Canadian Exhibitions', n.d. (c.1930) in NGCA.

31. J. A. Radford, 'Favoritism', *The Sun* (Vancouver), 20 Dec. 1932; H. Watson, 'Canadian Art at the British Empire Exhibition', *Saturday Night*, 6 Oct. 1923; E. Fosbery, 'As to Certain Myths', *The Journal* (Ottawa), 2 Feb. 1927.

32. 'Painters Demand the Head of Art Dictator of Canada', *The Star* (Toronto), 20 Nov. 1926.

33. 'Ottawa Artists to Protest the Selection of Pictures', *The Star* (Toronto), 24 Feb. 1927; E. Fosbery, 'Names One Great Canadian Picture Missing from List and Artists Wondering Why', *The Journal* (Ottawa), 25 Feb. 1927.

34. J. A. Radford, 'The National Gallery and B. C. Art League', *Saturday Night*, 3 Feb. 1923; H. Mortimer-Lamb, 'National Art Board Is Arraigned for Neglect of West', *The Province* (Vancouver), 8 Feb. 1925; J. A. Radford, 'Artists Slighted by Ottawa', *The Sun* (Vancouver), 14 Jan. 1930.

35. Eric Brown, London to H. O. McCurry, Ottawa, 29 May (1925) and Eric Brown, Paris to H. O. McCurry, Ottawa, 27 March (1927), both in NGCA.

36. Eric Brown, 'Canada's National Painters', *The Studio*, vol. CII (June 1932), pp.312-23.

37. 'Lismer Ridicules Favoritism Charge', *Varsity Review* (Toronto), 16 Dec. 1932; A. Y. Jackson, Toronto to H. O. McCurry, Ottawa, n.d. (c. 17 Dec. 1932). Newton McTavish had edited *Canadian Magazine* in Toronto from 1906 to 1926, in which he wrote many excellent articles on the major Canadian artists of the early part of this century, the same artists who were now senior academicians. McTavish was author of *The Fine Arts in Canada* (Toronto 1925) and *Ars Longa* (Toronto 1938).

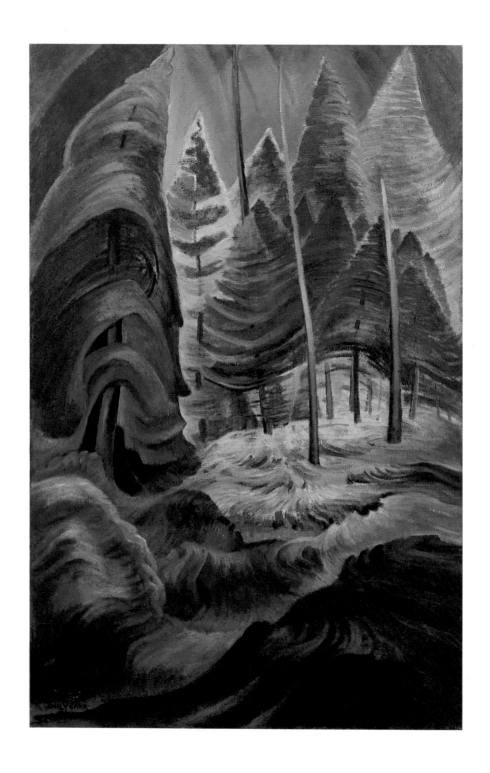

Emily Carr, *A Rushing Sea of Undergrowth,* 1935
Vancouver Art Gallery (cat. 10)

ART AS ACT: EMILY CARR'S VISION OF THE LANDSCAPE

Renfrew, August 14, 1929

What seest thou?
Cedar, pine, balsam, fir
Straight and tall, pointing always
to the blue sky, organized orderly
form. Tangles of dense undergrowth
smothering, choking, struggling,
in the distance receding plane
after plane, rising, falling – warm
and cold greens, gnarled stump
of grey and brown.

What hearest thou?
Whisperings, murmurings, now
loud, now soft, the trees talking,
squeakings, groanings, creakings,
sometimes tree trunks chafing
against each other, the saucy
screech of blue jay, the kingfisher's
clatter and the chatter of an
occasional squirrel, resenting my
intrusion.

What smellest thou?
The sweet smell of growing
things, of moist earth and sun-
ripening berries, the faint wild-
flower smell, the spicy smell
of new pine growth and the dear
smell of cedar when you crush it.

What feelest thou?
The reality of growth and life and
light, the sweetness of Mother
Nature, the nearness of God,
the unity of the universe,
peace, content.

What tastest thou?
The full, pure joy of life…

Emily Carr wrote 'Renfrew, August 14, 1929' when she was beginning to express in words and in paint her relationship to God through the forest landscape of coastal British Columbia. She was fifty-seven years old. The painting *A Rushing Sea of Undergrowth* (cat.10)[1] was executed a few years after Carr wrote the poem 'Renfrew'. That it is unlike any other work of art depicting the British Columbia landscape becomes clear when one compares it with other paintings of the area. The first European artists who visited the north-west coast of North America during the 1770s and worked within the categories of the sublime, the beautiful, and the picturesque had difficulty adapting their eighteenth-century perceptions to the land. Artists such as Captain Cook's John Webber chose to depict what they felt was exotic: the native Indians and their

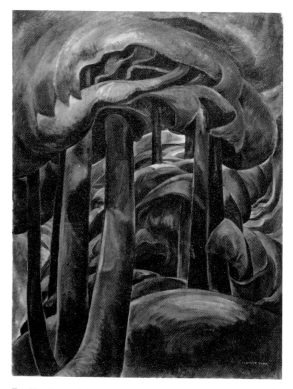

Emily Carr, *Western Forest,* c. 1931
Collection Art Gallery of Ontario, Toronto (cat. 5)

Portrait of Emily Carr in her studio

community houses. If the forest did appear in their work it was rendered as a silhouetted backdrop to the subjects that interested them more. By the late nineteenth century British Columbia's itinerant artists who came mainly from central Canada – T. Mowar Martin, F. M. Bell Smith, and Marmaduke Matthews, among others – had conventionalized the landscape to the point where the conifers appeared as muddy side-wings lying below mist-covered mountains. When they did venture into the forest to paint, which was rare, their work resembled a picture postcard to show the folks back home just how lush and overwhelming was the coastal vegetation of British Columbia. Even Emily Carr's contemporaries such as Paul Rand and W. P. Weston relied, when painting the land, on conventions that were borrowed from the Ontario Group of Seven and the American Scene Painters.[2] But in *A Rushing Sea of Undergrowth* Emily Carr goes beyond her 1930s

MARIA TIPPETT

contemporaries, beyond the artists who visited British Columbia in the eighteenth and nineteenth centuries because her vision is derived from the unique forms of the vegetaton itself. *A Rushing Sea of Undergrowth*, then, is more than an aesthetic object to be compared with photographs of the forest vegetation, or to be seen in stylistic relation to the works of Van Gogh or Soutine, or to be interpreted according to any other associations that it may arouse. It represents an historical event and being history it possesses causes and conditions both immediate and remote, public and private, patent and concealed without which it could not have been painted.[3] This then is the subject of my essay: the causes and the conditions that brought this work about and resulted in a break-through of landscape perception.

Before I discuss the immediate causes and conditions that made such a work possible, I would like to consider the two ways in which Emily Carr perceived the landscape before this happened. For over sixty years of her life she viewed the land in two ways. First through the myths, the iconography, and the spirit of the west-coast native Indians. And second through the late nineteenth-century British perception of the landscape shared by her fellow Victorians.

Emily Carr's perception of the landscape through what she perceived to be the native Indians special relationship to it was developed after an incident which Emily called 'the brutal telling'.[4] The incident occurred when Emily's father, Richard Carr, told and perhaps demonstrated to her, the facts of life. Now I do not want to dwell on this traumatic event which happened during Emily's early adolescence. But I do want to stress that whatever happened between Emily and her father contributed to an alienation which made her turn not only from Richard Carr, but from her entire family. A secondary outcome of this event, one that is important for the purposes of this discussion, was Emily's identification with the native Indians. I am not suggesting that Emily was unaware of the Coast Salish Indians in her native Victoria before this incident occurred. Indians were ubiquitous during her childhood. The Carr family's washerwoman, Mary, was a Coast Salish native. Emily saw Indians sitting on the steps of her father's warehouse waiting for a handout. And when she did not see them, she heard their voices as they drifted from the Songhees Reserve across the James Bay Harbour to her house on the edge of Beacon Hill Park. Yet it was only after 'the brutal telling', that Emily Carr began to identify with the native Indians in her midst. For example, she read Alexander Pope's *Essay On Man* and copied into a small cedar-bound book the passages that referred to the Indians' untutored mind, to their superiority over the 'civilized' European, and to their closeness to nature.[5] She painted the canoes and the houses on the edge of the Songhees reserve in Victoria. And in the summer of 1898, at the age of twenty-six, she travelled to the west-coast village of Ucluelet where her sister Lizzie was training to become a missionary. The trip was memorable for it was now that Emily acquired her Indian name, 'Klee Wyck' – meaning the one who laughs – now that she lived among the native Indians for the first time, and now that she saw just how closely their lives were linked to the tides and the seasons.

In 1910, three years after making this decision, Emily travelled to France to learn something of the modern school of painting so that she might record the totem poles and the community houses in a broader manner. There she began to employ heavy brush strokes, brighter colours, and a unifying outline. As a result, her work evolved from the exactness of the Romantic-Realists to the looser handling of the Post-Impressionists. Seventeen years after making this radical departure in style she met the Group of Seven from distant Ontario. While she immediately caught their enthusiasm for painting Canada in a new way and borrowed some of their inter-war conventions for her art, she chose to portray British Columbia not through the land as the Group of Seven portrayed Ontario, but through the native Indian motif. The degree to which Emily now set out to dramatize what she perceived to be the Indians' relationship to their guardian spirit and to the land is best seen in the painting *Blunden Harbour*.[8] Even though Emily never visited this village (she painted it from a photograph) she was nevertheless able to express what she felt to be the power residing in the totem figures as though she had been

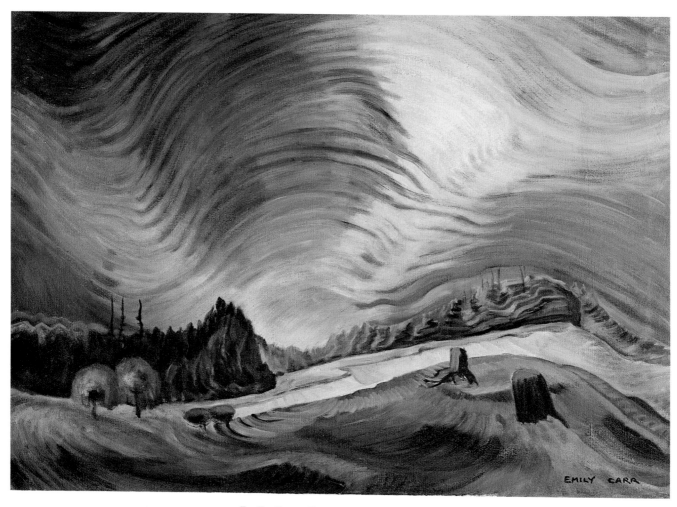

Emily Carr, *Above the Gravel Pit,* 1936-37
Vancouver Art Gallery (cat. 12)

working under them in the village. By enhancing the height of the hills, by adding clouds, by pushing the totem poles into the foreground of the picture, and by giving the light a definite source – it rises from behind the hills and moves around the poles – she was able to imbue the scene with a surreal awesomeness.

Emily not only perceived nature through what she felt to be the Indians' relationship to it, but, as I mentioned earlier, she shared the late nineteenth-century British settlers' vision of the land too. It was one that regarded the forest wilderness with fear and related that fear to God. From early childhood the forest had been inimical to Emily. She had watched settlers struggle to fell trees on the outskirts of Victoria. When Emily and her sisters picnicked in the heavily wooded area of Millstream on the fringes of the city they had remained on the stream's edge. And when Emily made her first excursion through the forest wilderness in 1895 in the company of her sister Alice and another girl – they cycled from the village of Duncan through a ten-mile stretch of dusty road to Lake Cowichan – she had recorded that the trees were tall and sombre, the forest 'dark, lonesome, silent, and gruesome'.[9] Even three years later when Emily travelled to Ucluelet for

MARIA TIPPETT

the purpose of portraying the native Indians she had either omitted the forest altogether from her watercolour paintings or had rendered it, in keeping with the late eighteenth-century artists of Captains Cook and Vancouver, as a silhouetted back-drop to the things that interested her more.

Emily's antipathy to the wilderness landscape lying north of Victoria was not really surprising. Her landscape aesthetic had been cultivated by the city's rolling meadows, Garry oak covered hills – a landscape that was quite different from the forest lying beyond Victoria's fringe. And as a motif for her art there was simply no precedent for painting the forest other than the muddy side-winged paintings of the itinerant artists from central Canada that she might have viewed at the Willows Fair or in the lobby of the Empress Hotel. Indeed it was quite fortuitous that Emily chose the forest as a subject for her work at all. And it happened not in Canada but in the fishing village of St Ives in Britain.

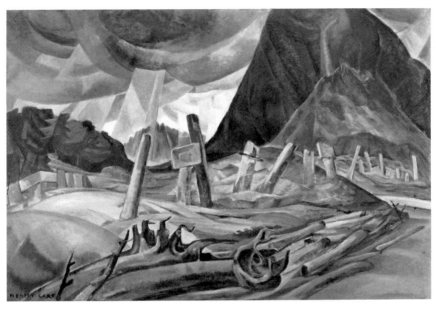

Emily Carr, *Vanquished,* c. 1931
Vancouver Art Gallery (cat. 6)

Emily did not climb the steep hill above St Ives harbour to paint in Tregenna Wood because she wanted a new subject for her art. She chose to set up her easel in the thickly wooded deciduous forest because there was no one looking over her shoulder while she painted, because she could avoid her incompatible teacher Julius Olsson, and, finally, because she could escape from the glare of the sun on the beach which was the source of her severe migraine headaches. Yet among the ivy-draped trees of Tregenna Wood Emily found more than a refuge from her teacher, the glare of the sun, and curious villagers. As she was later to recall, it was there that she was inspired 'to learn to express the indescribable depths and greenery' and there that she learned to see 'the coming and going of crowded foliage that still had breath space between every leaf'.[10] Although we have no way of knowing how Emily expressed this in her work at the time because there are no landscape paintings extant from her English sojourn, she did paint the giant-bowled cedars in Vancouver's Stanley Park when she returned to British Columbia. In *Wood Interior*[11] Emily attempted to capture the 'solemnity,

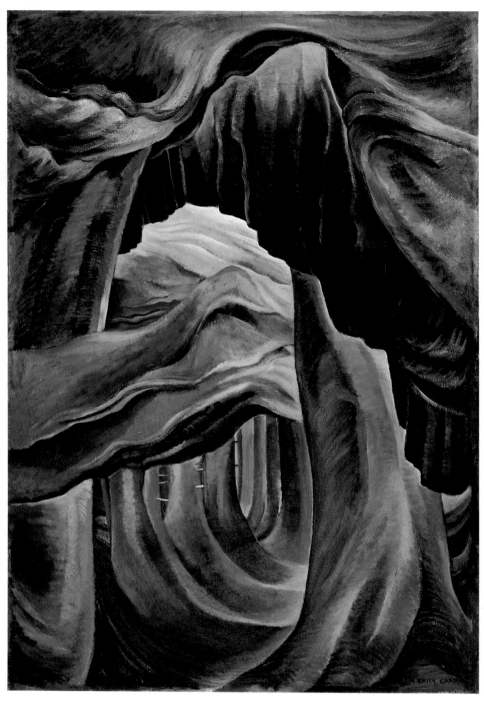

Emily Carr, *Forest B.C., 1932*
Vancouver Art Gallery (cat. 8)

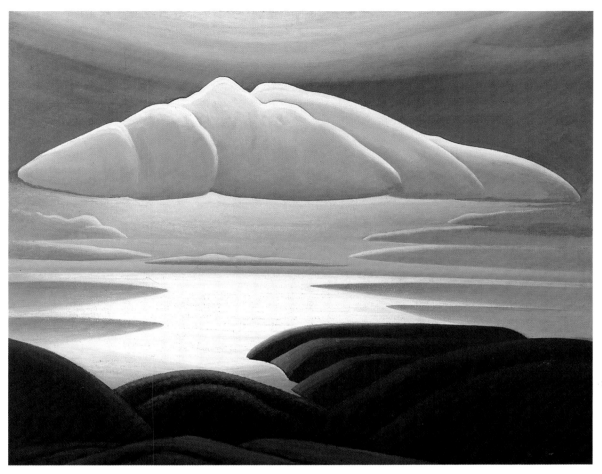

Lawren Harris, *Clouds, Lake Superior*, 1923
Collection of the Winnipeg Art Gallery (cat. 42)

majesty and silence' that she later remembered finding in Stanley Park's midst.[12] Yet the forest motif did not dominate her work at this time. Because it was in 1907, following her trip to Alaska, that she embarked on her mission to make as complete a record as possible of the native Indian villages in northern British Columbia. Consequently the forest, as rendered in *Skedans, Q.C.I.*,[13] was a mere back-drop for the totem poles and community houses. And it remained a back-drop until Lawren Harris of the Group of Seven told her in 1929 to abandon the Indian subject and develop her art forms from the forest landscape.

Emily followed Harris's advice and in the spring of 1929 she made an excursion to Nootka on the west coast of Vancouver Island. She travelled to the densely wooded Indian village for two reasons. First, when she had viewed Harris's paintings while visiting Toronto in 1927, she had been impressed by his ability to convey the spirituality of the northern Ontario landscape in his work. His paintings rose, she noted, 'into serene, uplifting planes, above the swirl into holy places'.[14] Second, she had been equally impressed by Harris's Theosophical outlook, a belief that professed a direct mystical apprehension of God. Consequently when she reduced the trees at Nootka to cones, spheres, triangles, and zig-zagging

lines and when she employed dramatic lighting she was working very much under the influence of Harris's thought and art.

But the idea that God resided in nature was one that Emily had long held. What Harris did was to give her a nudge, to show her that the artistic expression of God through nature was possible to achieve in her work. From such charcoal sketches as *Nootka*[15] Emily painted one of her most monumental canvases of this period. It is titled *Grey*.[16] By using a cool neutral palette of browns and greys and by reducing the forest growth to triangular shapes so that the trees no longer resemble their life models, Emily was able to unite the forest's surging growth into one beautiful structural whole. By so doing she had formalized her forest experience of fear and loneliness. The result was a unique expression of an omnipotent God dwelling in the primordial wilderness.

It was, therefore, only after Emily Carr met the Group of Seven and came under the influence of Harris, that her two perceptions of the wilderness – one based on the Indians' view of it, the other on the early European settlers' – that these two ideas came to fruition in her work. Yet as soon as this happened, as soon as she had found a means of expressing these two perceptions in her work, she was dissatisfied. First, by using the native Indian motif she had come to believe that she was not creating her own art forms, but copying an idiom that had already been developed by another artist: the Indian. Second, by expressing her relationship to the forest through the British settlers' fear of it she had also come to a dead end. Though *Grey* which epitomized this fear was her most intense painting at the time, she came to view the work as little more than a play because while painting it, as while painting *Blunden Harbour*, she had been more concerned with creating an effect than with revealing the spirit of her subject. Expressed in her art Theosophy, she now came to realize, was motionless, cold, and dominated by an ominous distant God. As a vehicle for her faith, Theosophy denied Christ, prayer, and the Bible. Not satisfied with confronting the wilderness landscape through either the native Indians' or the European settlers' rendering of it she set out to create her own vision. She was sixty when she embarked on this monumental quest.

From about 1930 Emily Carr directed all her energy towards expressing in her work her relationship to God through the forest landscape. To help her do this she read art books and studied their illustrations. She attended religious meetings, viewed the work of other artists, and purchased a caravan so that she could work in the forest undisturbed. It was now, during the early 1930s, that her genius for absorbing then discarding all but a small portion of an idea came to the fore. Now that art became an act of devotion that enabled her to come to terms with the forest wilderness. And now that the immediate causes and conditions for works such as *A Rushing Sea of Undergrowth* were laid.

Although one can choose almost any point during the early 1930s from which to plot the ideas and the influences that Emily absorbed then discarded, I should like to begin with 1930. That year Emily visited the Stieglitz Gallery in New York. There she met the American artist Georgia O'Keeffe and viewed her *Jack-in-the-Pulpit* series of flower paintings. At about the same time she discovered the work of the British sculptor Lawrence Atkinson in a booked titled *The New Art* (1929). When Emily returned to British Columbia after encountering the work of O'Keeffe and Atkinson she painted *Tree*.[17] Keeping the work of both artists very much in mind, she thrust her viewer against the trunk of the tree – just as O'Keeffe had thrown her viewer into the centre of the flower. She juxtaposed light and dark colours to achieve a rhythmic balance between the slow curving ascending lines of the trunk and the slow falling draperies of the background foliage. And she imbued the trunk with an inner tension that seemed to push out and thrust up – this resembled the dynamic structure and rhythm inherent in Atkinson's work.

Also during the early 1930s Emily Carr studied Mary Cecil Allen's work *Painters of the Modern Mind* (1929). The book imparted the idea of movement and rhythm in nature. It told Emily how the artist could give a painting a synthesis so

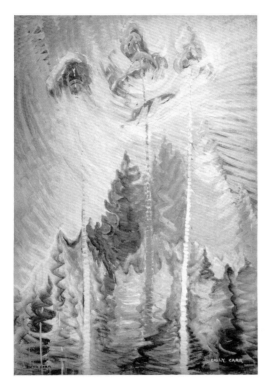

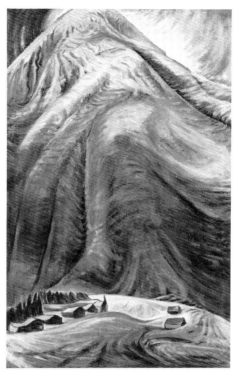

Emily Carr, *Untitled,* 1935-36
Vancouver Art Gallery (cat. 11)

Emily Carr, *The Mountain,* 1933
McMichael Canadian Art Collection (cat. 9)

closely knit and so organic that it obliterated the impression of several parts of movements and represented one complete structure.[18] The unity of movement about which Allen wrote was not, however, easy for Emily to achieve in her own work. When she attempted to infuse such canvases as *The Little Pine*[19] with movement she was unsuccessful. Though able to free the centre tree from its triangular encasement, she was unable to link it to the foreground underbrush which swims across the canvas or to the background trees which remain encased in their cones. Indeed Emily was only able to obtain the unity of movement about which Mary Cecil Allen wrote, when she began to use an oil-on-paper medium for sketching. By adding great quantities of turpentine to oil paint, then applying it with broad brushes to Manila paper, Emily discovered that she had the best of both the oil and the watercolour mediums. Unlike watercolour, the oil-on-paper medium did not dry a lighter hue, but retained the same intensity of colour. Unlike oil, which took hours to dry, this medium dried immediately. Thus one of Emily's greatest gifts as an artist was unleashed: her spontaneity. She could do three sketches a day, whereas is took several days, even weeks, to complete a canvas. And she did not have to worry about the cost of materials because the Manila paper, the house paint, and the turpentine was cheap. She therefore could, as she wrote, 'slash away because material scarcely counts'.[20]

Emily never intended any of her oil-on-paper sketches for exhibition and always felt that when they were shown it was a bit like having her underwear exhibited. These sketches were scales, excercises, notations. When she painted an oil canvas in her studio it was from two or perhaps more oil-on-paper sketches that she culled her ideas. Yet despite her belief that they were unexhibitable, some of her finest work is to be found in such sketches as *Sea and Sky*[21].

Lionel LeMoine (L.L.) FitzGerald, *Broken Tree in Landscape,* 1931
Collection of the Winnipeg Art Gallery (cat. 31)

Paralleling the influences of O'Keeffe and Atkinson, as well as her exposure to the writings of Mary Cecil Allen and her experimentation with the oil-on-paper medium was Emily's departure from Theosophy and her involvement in other esoteric religions. For example, in the spring of 1931 she partook in faith healings at the Unity Centre in Victoria. Around the same time she attended the lectures of a man called Harry Gaze who dealt with meditation and absolute communion with the divine. She also led a campaign to bring the Black New York faith-healer, Father Divine, to the city so that she might experience one of his five-second faith healings. While the ideas embodied in all of these beliefs — communion with God through nature — was the sort of teaching that struck a chord with Emily, she found that, as with Theosophy, there was something in them that was missing. Consequently in 1933 she returned to the faith of her youth: Christianity.

Emily Carr's departure from Theosophy coincided with her turning away from her associations with the Group of Seven and with the other friends that she had made in central Canada. Between 1933 and the beginning of 1936 not one

MARIA TIPPETT

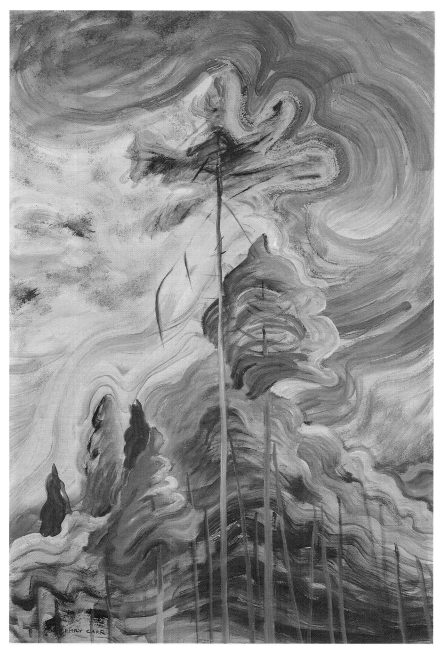

Emily Carr, *Sunshine and Tumult,* c. 1938-39
Art Gallery of Hamilton (cat. 13)

painting left her studio for exhibition in Toronto, Montreal, or Ottawa. This independence from exhibiting, from relying upon like-minded artists, coupled with her self-searching, her moulding of her life to fit her art was furthered in 1933 when she purchased a caravan. As I mentioned earlier Emily never liked anyone looking over her shoulder while she worked. The caravan, fondly call 'The Elephant', was a solution to her need for privacy. Secluded in the forest wilderness on the outskirts of Victoria there was no intrusion from Emily's apartment-house tenants, from her sisters, or from anyone else. Apart from the occasional weekend visitor she was now able to work undisturbed.

Working in the dense forset of Mount Douglas Park or the Gold Stream Flats, or on the bare rolling hills in Metchosin, Emily took a double approach to the landscape by writing about it before she painted it. She wrote of the small young pines as the forest's children; the towering elephant-legged cedars as their matrons. The loggers whom she saw racing through the woods in their noisey trucks were the tree's executioners. She showed evidence of their destruction in such paintings as *Logged-over Hill-side*.[22] She not only gave the trees human characteristics in her writings, but invested such paintings as *Scorned as Timber, Beloved of the Sky*[23] with anthropomorphic drama.

From 1933 to 1936, between the ages of sixty-two and sixty-five, Emily therefore came at last to terms with God, the forest, with her enforced landlady chores, even with her friends and sisters. As a result she created some of her most innovative paintings. Working in the oil-on-paper medium she developed a visual vocabulary which sorted out the chaos of the forest growth and gave the landscape an underlying structure and order. Using the full sweep of her arm she struck out rendering the foliage in S-curves, chevrons, and interlocking rings. Through a series of short vertical strokes she rushed her viewer from the foreground to the centre of the picture. By alternating the curves of the trees she created a surging rhythm. And in order to link all of these things in one sweeping movement thereby achieving the unity of movement about which Mary Cecil Allen had written, she integrated each brush stroke. This infused the sky, the trees, and the earth with an energizing force that expressed one thing: God in all.

By 1935 Emily Carr had reached the point where she could whirl any bit of forest or shore on to paper. Her sketches were the substance from which she now created such canvases as *A Rushing Sea of Undergrowth*. The causes that had brought this painting about, therefore, grew out of Emily's inner spiritual condition; out of her realization that her paintings must express that condition; and her discovery of a style and an appropriate subject-matter to express that spiritual condition. Emily's early alienation from her father and from her family required that she come to terms with her life through the inner spirit. She found that through a spiritual quest which began with her dual perceptions of the landscape through the Indians and the British settlers and was continued by studying Theosophy and other esoteric religions, and by fusing Christianity with some of these ideas. The realization that she must express that inner condition began when Emily first painted the forest in Tregenna Wood in St Ives but was only fully realized when she saw how Lawren Harris of the Group of Seven was expressing his spirituality and the spirit of the land through his art. The development of a style appropriate to that expression began in France, was continued through contact with the Group of Seven, then O'Keeffe, Atkinson, and Mary Cecil Allen. The conditions that allowed these causes to fulfil themselves in the act of painting were, among other things, the restructuring of her life to fit the primacy of her art by subordinating landlady chores to it; the achievement of isolation and propinquity in the forest by the purchase of a caravan; and, the discovery of the oil-on-paper medium for sketching.

Emily only had five years in which these causes and conditions fully operated. In January of 1937 she had her first heart attack. She did continue to make trips to the forest between 1938 and her death in 1945 but further heart attacks meant that she had to go in the compapny of a maid and live in a cottage rather than in her caravan. Sadly much of the work

resulting from these last trips in weak. Attempting to force the rhythm of the trees she added more turpentine to her paint, but the lines and the rhythm as seen in *Untitled*, 1935-36 (cat.11)[24] became uncertain. It was clear that without the isolation offered by 'The Elephant' and the health to walk among the trees and to commune with God through nature, Emily could not achieve that level of consciousness where she was no sex, no age, just a mindless part of the scents, the smells, the silence, and the colours of the forest described so well in her poem 'Renfrew, August 14, 1929'.

Art for Emily Carr was more than putting a bit of forest landscape on to paper. Art was an act. 'I myself am nothing', she wrote, 'only a channel for the pouring through of that whch *is* something'.[25] But art not only has causes, it has effects. Because in the act of painting the forest landscape Emily Carr has given Canadians, and, indeed, all visitors to the west coast of British Columbia, a way of seeing the forest vegetation that makes it impossible to view it without noticing the sweeping curves of the cedars, the jetting arms of the Douglas firs, and the great arching expanse of the sky.

NOTES

1. *A Rushing Sea of Undergrowth*, 1935. oil on canvas, 111.8 × 68.6cm, The McMichael Canadian Art Collection.

2. For a discussion of landscape painting in British Columbia see Maria Tippett and Douglas Cole, *From Desolation to Splendour: Changing Perceptions of the British Columbia Landscape* (Toronto 1977).

3. Peter Gay, *Art and Act: On Causes in History – Manet, Gropius, Mondrian* (New York 1976).

4. Provincial Archives of British columbia, Emily Carr Papers, Emily Carr to Ira Dilworth 'Tuesday', no date (1942-43). For a more complete discussion of this incident see Maria Tippett, *Emily Carr: A Biography* (Toronto 1979) pp.12-14.

5. See Alexander Pope's *Essay on Man*, Epistle I. The book in which Emily copied from line 99 to the end of the poem is in a Private Collection.

6. See Emily Carr, *Klee Wyck* (Toronto 1941) for an account of this excursion.

7. Provincial Archives of British Columbia, Emily Carr Papers, 'Unpublished Journals'.

8. *Blunden Harbour* (c. 1931), oil on canvas, 129.6 × 94cm, National Gallery of Canada.

9. *A Bicycle Trip to Lake Cowichan*, inscribed 'M. Emily Carr, July 23, 1895', Private Collection.

10. *Op.cit.*, Tippett, *Emily Carr: A Biography*, p.50.

11. *Wood Interior*, 1909, watercolour, 73 × 55.6cm, Vancouver Art Gallery.

12. Provincial Archives of British Columbia, Emily Carr Papers, 'Unpublished Journals'.

13. *Skedans, Q.C.I.*, 1912, watercolour, 75 × 53.3cm, Collection of Max Stern, Montreal.

14. Emily Carr, *Hundreds and Thousands: The Journals of Emily Carr* (Toronto 1966), 18 November 1927, p.7.

15. *Nootka*, 1929, charcoal, 62.2 × 48cm, Vancouver Art Gallery.

16. *Grey* (c. 1929-30), oil on canvas, 111 × 69cm, Art Gallery of Ontario, Toronto.

17. *Tree*, 1931, oil on canvas, 129 × 55.8cm, Vancouver Art Gallery.

18. Mary Cecil Allen, *Painters of the Modern Mind* (New York 1929) pp.47, 55.

19. *The Little Pine*, 1931, oil on canvas, 111.8 × 68.6cm, Vancouver Art Gallery.

20. *Op.cit.*, Carr, *Hundreds and Thousands*, 15 April 1934, p.107.

21. *Sea and Sky.*

22. *Logged-over Hill-side* (c.1940), oil on paper, 23½ × 34¼in, 59.7 × 87cm, National Gallery of Canada.

23. *Scorned as Timber, Beloved of the Sky*, 1935, oil on canvas, 44 × 27in, 111.8 × 68.5cm, Vancouver Art Gallery.

24. *Untitled*, 1935-36, oil on paper, 91.3 × 60.2cm, Vancouver Art Gallery.

25. *Op.cit.*, Carr, *Hundreds and Thousands*, 27 January 1933, p.34.

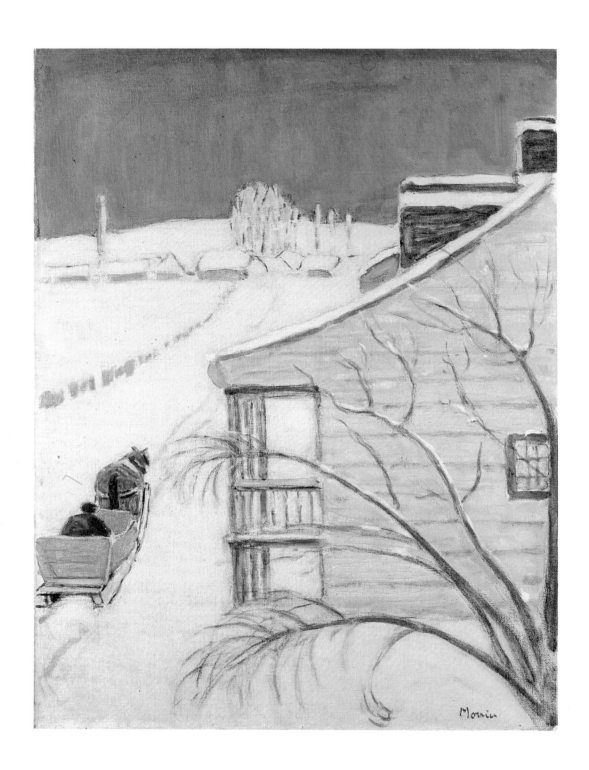

James Wilson Morrice, *Québec Farmhouse*, c. 1921
The Montréal Museum of Fine Arts Collection (cat. 97)

THE EXPRESSION OF A DIFFERENCE:
THE MILIEU OF QUEBEC ART AND THE
GROUP OF SEVEN

O Canada, terre des nos *aïeux*	O Canada, land of our *forefathers*
Ton front est ceint de *fleurons glorieux*	Your brow is crowned with *fleurons of glory*
Car ton bras sait porter *l'épée*, il sait porter la *croix*	As your arm can carry the *sword*, it can carry the *cross*
Ton histoire est une *épopée* des plus brillants exploits	Your history is an *epic* of the most brilliant feats
Et ta valeur, de *foi trempée*	And your valour, *soaked in faith*
Protégera nos *foyers* et nos *droits*	Will protect our *homes* and our *rights*

The considerable difference which exists between the French and English versions of the national anthem, this ideological song *par excellence*, stresses the co-existence of two distinct perceptions of the territory, which in turn support their different pictorial approaches to the Canadian landscape.

The English version insists on the 'true patriot love' which the Canadian brings to the 'true north strong and free', emphasizing a vision of Canada as a virgin region untamed, still to be conquered. As François-Marc Gagnon[1] pointed out, the space to which they refer is uncultivated land, which was one of the favourite themes of the Toronto painters of the Group of Seven and their innumerable imitators.

On the other hand, the French version of 'O Canada' values the 'fleurons of glory', and the 'feats' of those who, sometimes used the 'sword' to defend the 'cross', the 'faith', the 'land of our forefathers', 'the homes and their rights', and returns us to a way of life which existed prior to the English conquest. The geographical space which is referred to in this context is that of this cultivated land which is divided up and organized into parishes, villages and even towns. Here the countryside is perceived more like a humanized setting, never very far away from that traditional rural life which the clergy and certain élite of French Canadians believed, until the Second World War, to be the best way to guarantee maintaining the Catholic faith and the French language in North America. This vision of the territory was considerably different to that of the English-speaking people and its specific character formed the basis of the regionalist tradition in Quebec. Compared to its 'Canadian' counterpart, it had two peculiarities. Not only was the type of landscape reproduced very different from that of the northern regions, which were so dear to the painters of the Group of Seven, but, whereas the latter almost never portrayed man in their work, the Quebec artists also devoted an important part of their production to illustrating customs and traditional crafts. One can find numerous examples in the rather conventional illustrations of Edmond-J. Massicotte, but also in the work of those artists who, while having adopted more innovative techniques following

Alfred Laliberté, *Le Défricheur,* cover for
La Revue nationale, Montréal, vol. I no. I, January 1920

Edwin Holgate, *Village sous la neige,* cover for
La Revue populaire, vol. 21 no. 12, December 1928

their trips to Europe, were still no less instrumental in reinforcing this regionalist trend. Take, for example, the case of Clarence Gagnon and Suzor-Coté who continued to depict the Quebec landscape and many aspects of rural life (although it was coming to an end), while putting the bias on a formal, more modern and more subjective approach.

However, this interest in the Quebec landscape, indeed even in local mores, can also be found in the work of certain English-speaking painters. One can think of, among others, Horatio Walker, Maurice Cullen and James Wilson Morrice. However, I believe that the choice of these themes by English-speaking artists did not stem from the same ideological basis, and did not reinforce this traditional social plan, which was characteristic of the French-Canadian élite at that time. While the work of Walker was sold particularly on the American market, which was so fond of anything which reminded them of the Barbizon School, the work of Cullen and Morrice rather fostered a certain openness to modernity.

The twenties: the question of regionalism and the reception of the Group of Seven on the Quebec scene

This very conservative character which was generally present in French Canadian nationalism no doubt enables us to understand why the struggle against regionalism in art started in Quebec at the very moment when artistic nationalism in English Canada was gathering under the banner of 'modernity'. In fact it was in 1918, when the Group of Seven had not yet been officially created under this name, that an avant-garde Montreal review *Le Nigog,*[2] started to denounce regionalism which obscured the artist's and writer's freedom of expression and formal experimentation and restricted them in the name of fallacious national imperatives, which glorified patriotic virtues. 'A picture…depicting a corner of the country which is dear to us, will always evoke feelings in us which are unrelated to art…', wrote Fernand Préfontaine,[3] the architect and art critic of *Le Nigog.*

ESTHER TRÉPANIER

Nevertheless, it must be noted that this criticism of regionalism was only made by a minority of the avant-garde and it was not really taken up again until the thirties. The art critics of *La Revue nationale*, organ of the Société Saint-Jean-Baptiste showed that French-speaking clerical nationalism was an important ideological support for artistic regionalism. However, one must not forget that a good number of painters, both French- and English-speaking, developed a more modern approach to these regionalist themes or depictions of the Quebec landscape. This often enabled them to ingratiate themselves both to the defenders of nationalism and to the critics who were more open to thinking about artistic modernity. What is more, this even allowed certain critics to consider regionalism in painting as a positive element. So the works of Edwin Holgate, Marc-Aurèle Fortin and many others led Jean Chauvin, director of *La Revue populaire* and author of *Ateliers*, a work about Canadian artists, published in 1928, to declare:

'…like almost all Canadian artists, English and French, Holgate is clearly a regionalist. Yet, the manner in which all these artists express themselves reveals the effects of the education which they received abroad, particularly the influence of the School of Paris. Here one must beware of drawing parallels between regionalism in art and in literature. The former does not have any of the narrowness and the Jansenism of the latter.'[4]

Thus, at least until the end of the twenties, Chauvin declared himself open to regionalism in art as long as it did not mean the loss of original pictorial research and did not exclude openness to international trends. It is to this extent that he was interested in the Group of Seven, comparing their work to that of Marc-Aurèle Fortin. The latter's canvases, he wrote

Marc-Aurèle Fortin, *Grandes Ormes à Sainte-Rose,* c. 1926
Collection of Power Corporation of Canada (cat. 34)

W. Goodridge Roberts, *Laurentian Landscape,* 1939
The Montréal Museum of Fine Arts Collection (cat. 100)

in 1927, 'are charming and have real decorative value. He paints like certain members of the Group of Seven, in the same spirit. They are more knowledgeable but definitely not more pungent.'[5] For Chauvin, the painters of the Group of Seven, or others like Clarence Gagnon, should be counted among the founders of 'our modern school of landscape'.[6]

Along similar lines, a few years earlier, the critic from *La Presse*, Albert Laberge, having dealt with an exhibition of Lawren Harris at the Arts Club stressed that 'M. Harris belongs to a group of avant-garde artists…who are all endeavouring to portray as faithfully as possible the rough, wild and fierce sides of the Canadian land'. Harris, he said 'enables one to see the very soul of this land'.[7]

ESTHER TRÉPANIER

Clarence Gagnon, *Village in the Laurentians,* 1924
National Gallery of Canada, Ottawa (cat. 39)

But, despite these examples of a favourable reception, the Group of Seven was not unanimously accepted in Quebec. Although at the beginning of the twenties some saw the Group's innovative pictorial enquiry as interesting, it still stirred up many negative reactions. Some were, in fact, reported by Chauvin in his work *Ateliers.* Several of the painters he interviewed denounced the Toronto artists. Horatio Walker thought that they were 'gloomy and that they falsified the image of Canada';[8] Frederick S. Coburn stated that they mixed up 'eccentricity and originality' and that their painting was 'violent and brutal, like post-war literature';[9] for his part Hal Ross Perrigard thought that the decorative element in their work was too important and that they did not 'represent all Canadian art'.[10] In the end these criticisms were so numerous that Chauvin felt he had to look at this group again so that his book would not appear 'through no fault of our own, [as a] a catalogue of the complaints which were usually made by our painters against their friends in Ontario'.[11]

In fact the criticisms which Chauvin reported were those which were usually made in connection with the Group of Seven, and which have often been quoted by historians. Let us simply add that they were also echoed by the French-speaking defenders of the region and landscape of Quebec, who were devoted to defending their own culture. For them, the landscapes of the Group of Seven represented a different vision of Canada, they provoked ambiguous comments. Let

Paul-Émile Borduas, *Portrait of Maurice Gagnon,* 1937
National Gallery of Canada, Ottawa

us quote, for example, this article by Pierre Bourcier published in 1921 in *La Revue nationale*. The author is commenting on two canvases by A. Y. Jackson which were presented at the Royal Canadian Academy's Salon d'Automne:

'Let us turn to the landscapes which illustrate the rough, harsh and worn nature of Canada. Let us look at the canvases by Alex Jackson, the most wild and violent of the realists (...) Mr Jackson, who fought for civilization for four years in France, appears to want to distance himself as far as possible from civilization in his painting, and shows nature in its most wild and savage state.'[12]

In Quebec, the reactions to the Group of Seven in the twenties were not uniform. It would appear that they were conditioned by each individual's aesthetic and ideological approach.

The thirties: artistic modernity and criticism of nationalist landscape painting

Though the defenders of modern Canadian art in the twenties proved themselves to be more in favour of all the new tendencies in landscape painting, their positions were however to change at the end of the decade. So, by 1929, Jean Chauvin denounced the reigning art of landscape painting, which only yesterday had been, according to him, an innovative element in Canadian art.

ESTHER TRÉPANIER

'Our painters' inspiration appears to be short-lived. Each one has found his little formula for depicting the Quebec landscape, and does not want to move away from it any more…Maurice Cullen resists, as do Clarence Gagnon and Suzor-Coté because they are beautiful, conscientious painters. But what will happen soon to all those who have tacked onto the Group of Seven? Because we now have to admit that, with the most outrageous ease, the painters of Ontario have created a cliché. The masters of this movement remain great, but the painters who imitate them are merely making imitations, or forgeries or simply plagiarisms.'[13]

So, at the dawn of the thirties, landscape painting was on the way to becoming, in modern eyes, a stereotyped pictorial formula lacking in authentic and original vision.

Louis Muhlstock, *Winter Afternoon Place Ste-Famille,* 1940
Musée du Québec

It must be said that the thirties was a decade of extremely rich and complex transition as far as the development of the art world in Quebec was concerned. Parallel to the traditional, conservative and regionalist approaches which were maintained, other artists and art critics established a trend in favour of modernity and internationalism.

This trend was timidly expressed again by French-speaking painters like Adrien Hébert or Paul-Émile Borduas, and more openly by the young generation of English-speaking painters such as Philip Surrey, Goodridge Roberts and Marian Scott, as well as by artists who had recently immigrated to Canada like Fritz Brandtner, Alexander Bercovitch, Louis Muhlstock and Jack Beder. This movement was supported by a growing number of well-informed art critics, both French- and English-speaking, whose articles could be regularly read in *La Revue populaire, La Revue moderne, Le Canada* (by Henri Girard), *La Presse* ('Reynald'), *Le Jour, Le Standard* (Robert Ayre) and *The Montrealer* (John Lyman).[14]

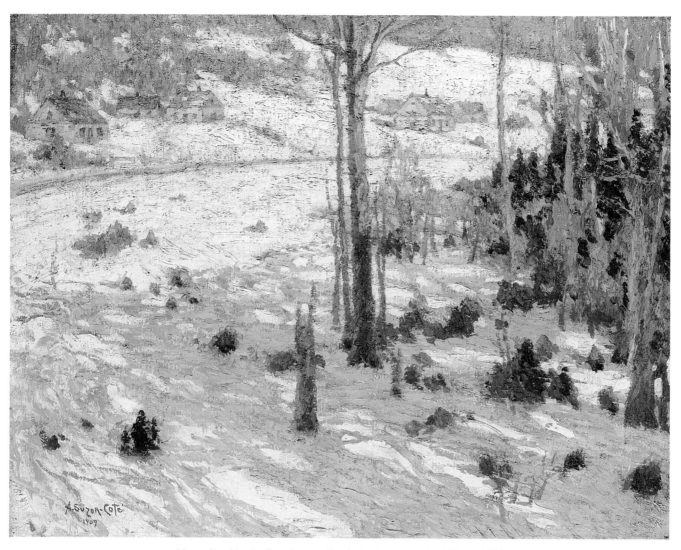

Marc-Aurèle de Foy Suzor-Coté, *Settlement on the Hillside,* 1909
National Gallery of Canada, Ottawa (cat. 19)

Beyond the individual differences, the notion of modernity which took shape in the thirties on the Quebec scene, and more precisely in Montreal, could be characterized as follows. In the first place, a denunciation of all notions about art which placed the value of the work on the subject-matter painted. The subject-matter was seen as being secondary to the originality of the artist's subjective expression, which could be seen in the quality of the formal work. Consequently, in maintaining that the subject-matter was not important implied a radical criticism of the trends which persisted in wanting to create a national art based on one theme, the landscape or soil.

Nevertheless, one must stress the fact that the opening up to international pictorial movements, such as Fauvism, Cubism and Expressionism, examples of which could be seen in Montreal in the thirties, did not go as far as Abstraction, apart from the odd exception. During this decade modernity was still expressed essentially within figurative art. Yet the

ESTHER TRÉPANIER

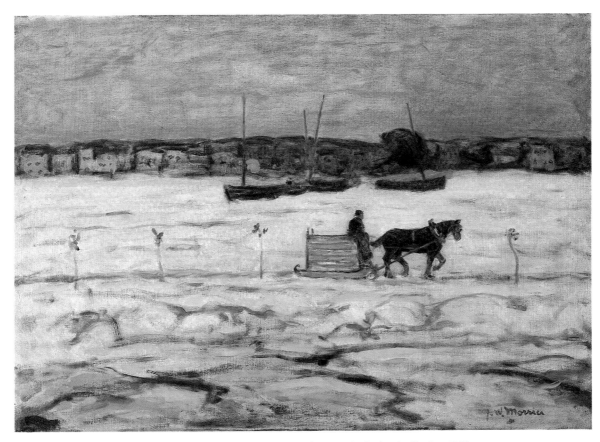

James Wilson Morrice, *Pont de Glace sur la Rivière St-Charles,* 1908
The Montréal Museum of Fine Arts Collection (cat. 95)

accent was now placed on the more subjective and more formal elements of the artistic work. Within this context, the attitudes adopted towards the Group of Seven and landscape painting in Canadian art changed appreciably.

The points of view of French speakers

Though Henri Girard expressed an interest in an exhibition of the Group of Seven in *La Revue moderne* in 1930, it was first and foremost because he thought that it was likely to encourage the debate around modern art:

'On hearing the news [the holding of the exhibition of the Group in Montreal] some said to each other "At last!", others said "Alas". Both the supporters and opposers went to the exhibition rooms with the secret desire to find arguments for or against modern art there.'[15]

Emphasizing the modernity of the Group, Girard declared again: 'the era of timid arts is over. At last we will know pure paintings'. So the Group of Seven did not interest him as a national school of painting, but as a modern group. Besides,

Marian Scott, *Fire Escape*
Musée du Québec

Adrien Hébert, *Elévateur à grain no 3,* c. 1930
Musée du Québec

Girard regularly denounced nationalism and regionalism in art and the 'clichés of the school of the soil'[16] in his article. In fact, that which was important for Girard was the creation of modern realism in painting, realism which rested on the originality of expression of a 'temperament'. That is why he valued the images of the modern town by Adrien Hébert just as much as the Expressionist works of Fritz Brandtner or the work inspired by the School of Paris by Alexander Bercovitch. The art reviews which he regularly published in the newspaper *Le Canada* reinforced this modern international trend. He maintained his opposition to this artistic nationalism which, according to Girard, feeds on deplorable xenophobia among the French-speaking people.

In the newspaper *La Presse*, 'Reynald' (pseudonym for E. R. Bertrand) found fault with nationalism in art which, until 1937, he set against a notion of art which he wished to define as being part of a humanist Christian thought, open to contemporary reality. He also recognized the merits of the Group of Seven but, like Girard, he was more interested in their pictorial contribution than in the creation of the so-called 'national landscape', which French-speaking people could scarcely identify with. So, his comments on the Group dealt, very pertinently, with the technical element which was peculiar to them:

'The Seven forced themselves to "rethink" the Canadian seasons, to idealize them in the synthesis of primary colours and rhythmic compositions…, in their own way they filled the gaps in drawing that existed in

Impressionism by making use of tonal values which were stylized into masses, cubes and squares and were usually made into straightforward cutouts…'[17]

At the same time he denounced the numerous imitators who reacted severely following in the footsteps of the Group and made ironic remarks about the 'mounds of "Jello"', the 'giant mushrooms' and the 'clouds of whipped cream' which Harris is supposed to have discovered on the banks of Lake Superior.

However, Reynald literally became converted to modern art during 1937. This conversion bears witness to the increasing importance of the debate surrounding modernity at the end of the decade in Montreal. His attitude towards the Group of Seven changed following the emergence of new artistic trends, like those among the Eastern Group of Painters formed in 1938 under the care of John Lyman. The Eastern Group of Painters, writes Reynald, were different from the Group of Seven:

> 'As far as one is living and the other is well dead, emptied of its own substance and diluted into the Group of Twenty-Eight…The old Group made use of its imagination to create a Canadianism which was picturesque and strong; the new one, at a more advanced period, makes more use of reason and does not at all repudiate obvious affiliations with the School of Paris. Even in its strongest works the old group was decorative; the new group draws from the most sane realism…One can expect a lot of a Group who can concentrate a resolutely modern message in one beam of light and colour…'[18]

At the end of the decade the Group of Seven had lost its aura as a modern group for the clan of French-speaking people, still in the minority, who were open to modernity. It became a school of landscape painting, having bred too many copyists. Henceforth Montreal rose socially to become the 'home of contemporary art' as indicated in the title of an article by Reynald.[19] From then on the national landscape came to represent a curb on modern thoughts. Painted by French speakers it was associated with a backward social ideology, and among English-speaking artists it had become a pictorial theme which had been too often abused. Even though straight after the First World War the Group of Seven had been successful in imposing the idea that Canadian modernism lay in the depiction of the national territory, at the end of the thirties this notion was questioned again by artists and critics in Quebec, who maintained that any subordination of art to the constraints of the subject-matter painted was an obstacle to the development of a truly modern approach.

The points of view of English speakers

On the side of the Anglo-Montreal critics, the painter John Lyman was certainly the one who most clearly expressed the new notion of artistic modernity. Indeed, he wrote:

> 'The essential qualities of a work of art lie in the relationships of form to form, and colour to colour'…The prevalence of a literary and sentimental point of view coupled with a representational technique resulted in a degradation of all the 'plastic' arts.'[20]

Since his return to Canada in 1931, following a long trip abroad, Lyman was an important initiator in regrouping

Lawren Harris, *Autumn, Algoma,* 1920
Victoria University, University of Toronto (cat. 43)

modern artists, prompting the creation of the Eastern Group of Artists and the Contemporary Art Society. He organized numerous exhibitions in order to diffuse modern work in Canada, and he contributed to initiating the public to contemporary art through the art reviews which he published in *The Montrealer* from 1936 to 1942. He was, without doubt, one of the most articulate opponents to the Group of Seven and the nationalism which inspired them. Did he not write in 1932, slightly ridiculing this spirit of adventure which made them tramp through the northern regions looking for landscapes to paint?:

> '…The real adventure takes place in the sensibility and imagination of the individual, [the] real trail must be blazed towards a perception of the universal relations that are present in every parcel of creation, not towards the Artic circle.'[21]

Yet John Lyman was not the only Anglo-Montreal critic to defend the modernist position. Robert Ayre, first in the *Gazette*, then particularly in the *Standard* from 1938, revealed himself to be an attentive observer of the artistic scene at

Sarah Roberston, *Storm Como,* undated
Agnes Etherington Art Centre, Queen's University, Kingston (cat. 101)

the same time as a remarkable commentator on contemporary art. If for him the Group of Seven remained a group of admirable pioneers who, in his time, had been 'a small compact army, fighting for a new, a dynamic, a Canadian way of looking at Canada, consolidating its position, attacking prejudice and stable tradition',[22] his interest was directed more towards that which, for him, represented the current expression of modernity in Canada. So he hotly defended all those 'Montrealers', those artists who were developing an art concerned with a 'more contemporary Canadian scene' using themes, often man or the towns, which did not curb innovative pictorial research. It is certain that for Ayre one of the merits of the Group of Seven was that they had been 'adventurous' enough 'to accept others adventures', and to leave room for the Canadian Group of Painters and for new trends, which he spoke about in these terms:

'…It wants to be critical rather than patriotic – for the work of the Group of Seven is a kind of joyous patriotism, though it praises terrain rather than people; *tells itself that it wants to come to grips with life; anyway it wants more*

humanity in its work: it would just as soon paint a Montreal Slum as Georgian Bay. *It tells itself too, that it wants to come to grips with painting*, and is not satisfied with bold decorations.'[23] [our underlining]

This quote, an extract from an article of 1939, reveals to us quite well the state of the debate in the Anglo-Canadian milieu. The 'patriotic' tradition of the northern landscape was held up, but it was exposed to a growing number of critics all over Canada and especially in Montreal.

Some of these critics came from the Canadian intelligentsia of the left, among whom were Barker Fairley, Frank Underhill and Paraskeva Clark from Toronto who wrote in *The Canadian Forum* (an organ of the social democratic Commonwealth Cooperative Federation) or in *New Frontier* (a cultural review of the so-called 'united front', published under the direction of the Canadian communist party). As a rule, they advocated, in both art and literature, a return to man, to social and contemporary realities which the bards of the landscapes of Pre-Cambrian Bouclier completely obscured. This interest in the human condition was maintained by the unsettled socio-political situation, resulting from the Depression and the rise of fascism. In addition, the American cultural policies adopted under Roosevelt's New Deal which encouraged the development of an art which was involved with social concerns then became an example which several Canadians followed.

But criticism of the Group of Seven did not only come from those who advocated the return to man, in terms of greater social engagement, as an artistic and literary theme. It also came from those who, in increasing numbers, said they 'want to come to grips with painting'. As Lyman wrote, henceforth it was now simply the pictorial element, the relationship between forms and colours which was important for them. The founding of the Contemporary Art Society in Montreal in 1939 showed that this trend had developed to a sufficiently strong and confident position for this organization to be formed to defend and promote it. The artists who were members of this society were infinitely less interested in landscape painting than their predecessors, and if they sometimes did use this pictorial theme, as for example Goodridge Roberts or Stanley Cosgrove, it was in order to treat it from a formal point of view, devoid of nationalist impulses. Besides, in an article on the exhibition *Art of our Day* in Canada John Lyman is glad about the fact that they had distanced themselves from this:

'...consecrated pattern, which we where erstwhile adjured to believe was the Canadian Tradition. Gone are the posters, gone the "designs" of the wilderness. Landscape has lost its quasi-monopoly as a motive for free expression; not more than a quarter of the pictures belong to this class. Forty per cent of the contributors are artists who deal, though not all exclusively, with the human subject.'[24]

In 1940 Lyman commented, just like Robert Ayre,[25] on the conference organized by Fairley in Montreal, in which he took up the struggle for man to be represented in Canadian painting, and stressed that more non-academic artists would devote themselves to this if they had 'any chance of making a living thereby'.[26] On the other hand, Lyman always asserted that subject-matter is an element secondary to the artistic work:

'A true painter does not learn to paint things, he learns to express his feelings and thoughts.'[27] 'The real subject is somewhere behind it. In this sense it has been said that every artist has but one subject. It can only become apparent in the way he paints. The emotion can only manifest itself in the technique – in the broadest sense.'[28]

Clarence Gagnon, *In the Laurentians, Winter,* 1910
National Gallery of Canada, Ottawa (cat. 36)

The creation of the Contemporary Art Society marked the end of the hegemony of a pictorial genre, that of the national landscape, which, as Dennis Reid reminds us, after having already known hours of glory in the 1880s,[29] had dominated the first decades of the twentieth century, interpreted in different forms by French- and English-speaking artists. But the creation of a Contemporary Art Society did not only announce the end of a certain type of Canadian art. It also permanently established a concept of modern art which would allow contemporary trends to develop on the Canadian artistic scene, such as a late form of Cubism, Surrealism and particularly Abstraction, which became especially effervescent in the forties with the Automatist movement led by the painter Paul-Émile Borduas.

Under the circumstances, the virulent remarks made by conservative artists and critics, who were well aware that the control of the art milieu was henceforth escaping them, are not surprising. So it was that Clarence Gagnon, although he was considered one of our foremost modern painters of his time, pronounced in 1939 at the Pen and Pencil Club, on the eve of the first exhibition organized by the Contemporary Art Society (a conference entitled 'The Grand Bluff of Modernist Art',[30] that he denounced contemporary art, in terms close to demagogy and racism.

One can say that differences in the art world had multiplied in the early forties. From the beginning, two distinct visions of the national territory were behind a great deal of the work produced by English-Canadian and French-Canadian painters. In the inter-war period, as an artistic trend developed which called for a more universal and international understanding of modernity, a growing dissociation between landscape painting and modernism asserted itself. Since this trend met with strong opposition from those with conservative inclinations, whether they were English- or French-speaking, the advent of modernity did not initially form a point of opposition between French and English Canadians. On

Clarence Gagnon, *Les Laurentides L'Hiver,* c. 1920
The Montréal Museum of Fine Arts Collection (cat. 38)

the contrary, this modernity was defended by people in varied cultural milieux. In fact, at the end of the thirties the rift seemed to be particularly between Montreal and Toronto. Robert Ayre admirably synthetized this opposition in an article which he published in 1948 'Observation on a Decade':

> '[The Group of Seven]…was centered on Toronto and for years it looked as if Toronto were the hub of Canadian painting. Toronto, you might say, made the most noise. But with Brymner, Morrice and Lyman for influences, Montreal has long had a powerful tradition of its own, and with the rise of men like Alfred Pellan, Stanley Cosgrove, Paul-Émile Borduas and Jacques de Tonnancour, and their followers, it might be said that the center of gravity has moved to Montreal. This is natural enough when you consider the shift in emphasis from Canadian painting to painting for its own sake. …Montreal is much less provincial than Toronto and the Spirit that made the School of Paris, unrestricted by any national sentiment, is at home there.'[31]

If the concept of artistic nationalism, and the hindrance which it posed to the development of modern art, had temporarily united different linguistic groups in the same struggle at the end of the thirties and reinforced, the Montreal/ Toronto opposition, what Ayre did not realize was that this union was drawing to its close. Indeed, a few months after

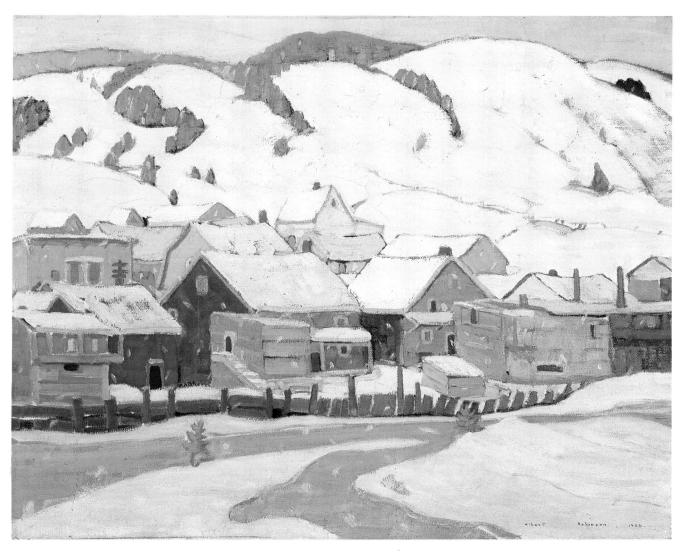

Albert H. Robinson, *Falling Snow, Les Éboulements,* 1926
Art Gallery of Hamilton (cat. 103)

Ayre published this article which we have just quoted, Borduas and members of the Automatist group brought about the dissolution of the Contemporary Art Society. They also published the manifesto *Refus global* (Total Refusal) which very highly asserted the avant-garde status of this group of abstract painters, which was almost exclusively made up of French-speaking artists.

The *Refus global* also announced, in its criticism of Quebec society, the rise of a new French-speaking intelligentsia which was the basis of the major transformations which took place in Quebec in the post-Second World War period under what is generally called the Quiet Revolution. In the post-war period, modernity was to become more and more overtly coloured by the French-speaking population. A new national feeling was to develop, not centred on Catholicism and tradition, but on a language and a culture which asserted both its modernism and its eminence at the same time.

NOTES

Translated from an original French text and printed in English with the author's permission.

1. François-Marc Gagnon, 'La peinture des années trente au Québec', *The Journal of Canadian art History/Annales d'histoire de l'art canadien*, vol.III, nos.I and 2, 1976, pp.2-20.

2. Nigog: 'mot d'origine sauvage désignant un instrument à darder le poisson et particulièrement le saumon' (Sylva Chapin, *Dictionnaire canadien-français*: quoted in no.I of *Le Nigog*, January 1918). Concerning this cultural avant-garde journal which appeared in Montreal in 1918, cf. the joint publication of the Archives des Lettres canadiennes, vol.VII, *Le Nigog*, Montreal, Fides, 1987.

3. Fernand Préfontaine, 'Le Sujet en art', *Le Nigog*, no.2, February 1918, p.44.

4. Jean Chauvin, 'A l'atelier d'Edwin Holgate', *La Revue populaire*, vol.20, no.2, February 1927, p.9. For an analysis of the status of Chauvin, cf. my article 'Deux portraits de la critique d'art des années vingt Albert Laberge et Jean Chauvin', *The Journal of Canadian Art History/Annales d'histoire de l'art canadien*, vol.XII, no.2, 1989, pp.141-73.

5. Jean Chauvin, 'Chez le peintre Marc-Aurèle Fortin', *La Revue populaire*, vol.20, no.9, September 1927, p.7. Chauvin is also aware of the question of the influence of Scandinavian painting on the group of Seven. He emphasized it several times and returned to it in an article he published on 'L' influence de la peinture française sur la peinture canadienne', *La Revue populaire*, vol.30, no.8, April 1937, pp.5 and 50.

6. Jean Chauvin, *Ateliers, Etudes sur vingt-deux peintres et sculpteurs canadiens*, Toronto, Montreal, New York, Louis Carrier et Cie, Les Editions du Mercure, 1928, p.210.

7. N. S. (Albert Laberge), 'Exposition de paysages par Lawrin (*sic*) Harris au Arts Club', *La Presse*, 3 March 1924, p.2.

8. Jean Chauvin, *Ateliers, op.cit.*, p.81.

9. *Ibid.*, p.135.

10. *Ibid.*, p.184.

11. *Ibid.*, p.214.

12. Pierre Bourcier, 'Notre Salon d'Automne', *La Revue nationale*, vol.II, no.I, January 1921, p.8.

13. Jean Chauvin, 'La Société des Sculpteurs du Canada', *La Revue populaire*, vol.22, no.6, June 1929, p.8.

14. For the 1930s, cf., among others, the catalogue by Charles C. Hill, *Canadian painting in the thirties*, Ottawa, The National Gallery of Canada, 1975, the text quoted in note I of F-M. Gagnon, i.e. the article I edited, 'La peinture des années trente au Québec', for the issue on 'Esthétiques des années trente' in the journal *Protée*, vol.17, no.3, autumn 1989, Université du Québec à Chicoutimi.

15. Henri Girard, 'Les "Sept" à Montréal', *La Revue moderne*, vol.II, no.10, August 1930, p.8. For an analysis of modern criticism in Montreal of this period, cf. my chapter on 'L'émergence d'un discours de la modernité dans la critique d'art (Montréal 1918-39)', in the joint publication, *L'avènement de la modernité culturelle au Québec*, Yvan Lamonde & Esther Trépanier (eds), Quebec, Institut québecois de recherche sur la culture, 1986, pp.69-112.

16. Henri Girard, 'Suzor-Coté, L'Exemple', *La Revue moderne*, vol.II, no.3, January 1930, pp.5 and 55.

17. 'Reynald' (E. R. Bertrand), 'Les Sept auront aéré notre art', *La Presse*, 18 April 1936, p.31.

18. 'Reynald', 'Notre Groupe de l'Est a de l'âme', *La Presse*, 3 December 1938, p.55

19. 'Reynald', 'Montréal, foyer de l'art contemporain', *La Presse*, 3 June 1939, p.32.

20. Quoted by E. P. Lawson 'Chronologie', in the catalogue *John Lyman*, Montreal, Museum of Fine Arts, 1963.

21. Quoted by Dennis Reid, *A concise history of Canadian painting*, Toronto, Oxford University Press, 1973, p.196.

22. Robert Ayre, 'Observations on a Decade…1938-48 – Recent developments in Canadian painting', *Journal of the Royal Architecture Institute of Canada*, vol.25, no.I, January 1948, p.12.

23. Robert Ayre, 'Significant Exhibition At Toronto By Diligent Canadian Group of Painters', *Montreal Standard*, 13 January 1940, p.M-6.

24. John Lyman, *The Montrealer*, 1 December 1940, p.20, quoted by Louise Déry in *L'influence de la critique d'art de John Lyman dans le milieu artistique québecois de 1936 à 1942*, mémoire de maîtrise, Faculté des Lettres, Université Laval, February 1982, p.135. For Lyman, cf. also the catalogue by Louise Dompierre, *John Lyman 1886-1967*, Kingston, Agnes Etherington Art Center, Queen's University, 1986.

25. Robert Ayre, 'Force and Direction of Newer Painting Under Criticism' (sub-title 'Prof. Fairley's Advice to Canadian Artists is to turn Attention to Human Subjects'), *Montreal Standard*, 20 January 1940, p.M-7.

26. John Lyman, 'Art: CAS Exhibition; Man in Art', *The Montrealer*, 1 January 1940, p.19, quoted by Déry, *op.cit.*, p.146.

27. *Ibid.*, p.147 from *The Montrealer* of 15 March 1937, p.23.

28. *Ibid.*, p.148 from *The Montrealer* of 1 February 1940, p.21.

29. Dennis Reid, *'Notre patrie le Canada', Mémoires sur les aspirations nationales des principaux paysagistes de Montréal et de Toronto 1860-1890*, Ottawa, National Gallery of Canada, 1979. There also exists an English version of this publication, entitled *Our Own Country Canada*.

30. This conference by Clarence Gagnon was later translated and published. Cf. 'De l'immense blague de l'art moderne', *Amérique française*, vol.7, no.I, 1948, pp.60-65 and vol.7, no.2, 1948-49, pp.44-48.

31. Robert Ayre, 'Observation on a Decade…', *loc.cit.*, pp.13-14.

J. W. Beatty (1869-1941)

Beatty led a colourful life, working as a fireman and serving in the Government force which suppressed the Riel Rebellion in the northern prairies. He began studying art in 1894. He also studied in Paris before travelling in Europe. Settling in Toronto in 1909, he formed part of the circle of artists who believed in the importance of the north as an expression of Canadian subject-matter. One of the first incumbents of the Studio Building, and a frequent visitor to Algonquin Park, his work bridges the tonal approach of the older Toronto artists and the content and richer technique of the Group of Seven.

1. **Beech Tree** 1916
oil on canvas, 63.5 × 101.6cm
Hart House Permanent Collection
University of Toronto

2. **October, Smoke Lake, Algonquin Park** (undated)
oil on panel, 21.6 × 26.7cm
Art Gallery of Windsor Collection
Gift of Mr and Mrs H. C. Hatch, 1971

Frank Carmichael (1890-1945)

The youngest of the artists who met at Grip Engraving, he was one of the original Group of Seven. He continued working in commercial art, and taught at Ontario College of Art for much of his life. As in his searching use of watercolour, his art has a linear quality which exemplifies the links between the Group of Seven and graphic design. His life was cut short just as he was beginning to explore a new interest in abstraction. His work's high-keyed, dense surface colour was part of a deliberate exploration of the 'decorative' elements of painting.

3. **Autumn** c.1922
oil on hardboard, 26.6 × 30.5cm
Collection of Winnipeg Art Gallery
Gift of Mr Peter Dobush

4. **Fanciful Autumn** (undated)
oil on canvas, 63.8 × 76.6cm
University College, University of Toronto

Emily Carr (1871-1945)

Carr grew up in Victoria, British Columbia's quiet capital. Throughout her early life she was in thrall to her father and sisters, rebelling against the expectations of female life. Studying in San Francisco and later in London, she never found a happy working atmosphere in studio surroundings. Her breakthroughs came when she worked in the country, first in Bushey and then, after a third attempt at formal study in Paris in 1910-11, in Concarneau, Brittany. She was then forty. Until 1927 she worked haltingly, earning a living as a reluctant landlady. Her work often depicted the totems of the west-coast Indians. As such it was often, mistakenly, appreciated as anthropological documentation. In 1927 Eric Brown included her work in a National Gallery of Canada exhibition of west-coast art, and travelling east she met the Group of Seven. Their attitudes were a spur to her, in particular Harris's Theosophic beliefs. This moment was the beginning of an extraordinary body of work. At the end of her life, unable to paint, she wrote a series of autobiographical books which added to her fame.

5. **Western Forest** c.1931
oil on canvas, 128.3 × 91.8cm
Collection Art Gallery of Ontario, Toronto

6. **Vanquished** c.1931
oil on canvas, 92.1 × 128.9cm
Vancouver Art Gallery
Emily Carr Trust

7. **Abstract Tree Forms** c.1931-32
oil on paper, 61 × 93.5cm
Vancouver Art Gallery
Emily Carr Trust

8. **Forest, British Columbia** c.1932
oil on canvas, 130 × 86.5cm
Vancouver Art Gallery
Emily Carr Trust

9. **The Mountain** 1933
oil on canvas, 111.4 × 68cm
McMichael Canadian Art Collection
Gift of Dr and Mrs M. Stern
Dominion Gallery, Montreal

10. **A Rushing Sea of Undergrowth** 1935
oil on canvas, 111.8 × 68.6cm
Vancouver Art Gallery
Emily Carr Trust

11. **Untitled** 1935-36
oil on paper, 91.3 × 60.2cm
Vancouver Art Gallery
Emily Carr Trust

12. **Above the Gravel Pit** 1936-37
oil on canvas, 76.8 × 102.2cm
Vancouver Art Gallery
Emily Carr Trust

13. **Sunshine and Tumult** c.1938-39
oil on paper, 87 × 57.1cm
Art Gallery of Hamilton
Bequest of H. S. Southam, 1966

14. **The Old Fir Tree** c.1940
oil on paper on board, 85.7 × 57.5cm
The Edmonton Art Gallery Collection
Gift of H. S. Southam, 1945

Alfred J. Casson (1898)

Grew up in Toronto, and worked in commercial art alongside Carmichael. He joined the Group of Seven in 1926 when Frank Johnston left. Like Carmichael, his art is studied and carefully composed around a clear linear style.

15. **Autumn Evening** 1935
oil on canvas board, 101.6 × 153.1cm
Hart House Permanent Collection
University of Toronto, Canada

Paraskeva Clark (1898-1986)

Born in Leningrad, she studied at the Fine Art Studios under Shykhayer and Petrov-Vodkin. She lived in Paris 1923-31, until she moved to Toronto with her Canadian husband. A member of the Canadian Group of Painters, her occasional landscape work emerges from a body of figurative or urban images which often surveyed social critique.

16. **Swamp** 1939
oil on canvas, 76.2 × 50.8cm
Collection Art Gallery of Ontario, Toronto
Gift from the Albert H. Robson
Memorial Subscription Fund, 1939

Charles Comfort (1900)

A Scot whose family immigrated in 1912 to settle in Winnipeg, he worked in commercial art in Winnipeg before moving to Toronto. He frequently returned to Winnipeg, but found being close to the Group of Seven and the centre of activity in Toronto important. His landscape work was matched by some memorable figurative images which have prompted comparisons with the American regionalist painters of the Depression. Comfort went on to be President of the Royal Canadian Academy 1957-60 and Director of the National Gallery of Canada 1960-65.

17. **Prairie Road** 1925
oil on canvas, 114.3 × 84.1cm
Hart House Permanent Collection
University of Toronto

18. **Tadoussac** 1935
oil on canvas, 76.2 × 91.4cm
National Gallery of Canada, Ottawa

Marc-Aurèle de Foy Suzor-Coté (1869-1937)

Suzor-Coté grew up in Arthabaska, Quebec. He studied in Paris (1890-93) and returned regularly to Paris, whilst dividing his time in Canada between Montreal and his family home in Arthabaska. While debate surrounds whether he was the 'first' Canadian Impressionist, he, like Cullen, saw the snow-laden bands of rivers and roadways as a perfect vehicle for the Impressionist manner. He also showed with Gagnon an interest in 'habitant' life, producing portraits of villagers in parallel to landscapes.

19. **Settlement on the Hillside** 1909
oil on canvas, 58.4 × 73cm
National Gallery of Canada, Ottawa

20. **Sugar Bush, Edgewater Farm**
oil on canvas, 60.4 × 73cm
Collection of Power Corporation of Canada

Maurice Cullen (1866-1934)

Born in St John's, Newfoundland, his family moved to Montreal in 1870. He studied in Paris 1889-92 and worked in rural Quebec with William Brymner and J. W. Morrice. His paintings were shown in the exhibitions of the Canadian Art Club, along with Suzor-Coté, Morrice and others, bringing advanced ideas from Montreal to the Toronto audience. This has meant his being cast in many histories as a 'precursor' of the Group of Seven, even though he continued painting into the 1930s; he also made a notable contribution to the Canadian War Records scheme.

21. **Quebec from Levis** 1904
oil on canvas, 72.4 × 92.1cm
The Montreal Museum of
Fine Arts Collection
Presented by James Reid Wilson

22. **Levis from Quebec** 1906
oil on canvas, 76.2 × 102.2cm
Collection Art Gallery of Ontario, Toronto
Gift of the Albert H. Robson
Memorial Subscription Fund, 1940

23. **Old House, Montreal** c.1908
oil on canvas, 61.4 × 86.7cm
The Montreal Museum of
Fine Arts Collection
Gift of the Honourable
Marguerite Shaughnessy

24. **The North River** c.1932
oil on canvas, 76.8 × 101.5cm
The Montreal Museum of
Fine Arts Collection
Dr and Mrs C. F. Martin Fund

25. **Logging in Winter, Beaupré** 1896
oil on canvas, 63.9 × 79.9cm
Art Gallery of Hamilton
Gift of the Women's Committee, 1956

Lionel LeMoine (L.L.) FitzGerald (1890-1956)

Brought up in Winnipeg, he remained rooted in that city all his life. Important visits to the U.S., including as a student in the early 1920s, convinced him of the historical importance of classic modernism, particularly the work of Seurat and Cézanne. Teaching at Winnipeg School of Art occupied much of his time and his art moved slowly but surely, culminating after the Second World War, in delicate still-lifes and abstract work which only recently have become recognized as ranking alongside his landscape masterpieces of the 1930s, when he was briefly a member of the Group of Seven.

26. **Sketch for 'Poplar Woods'** 1927
pencil and ink on paper, 23.7 × 31.8cm
Collection of the Winnipeg Art Gallery
Purchased in memory of Mr and
Mrs Arnold O. Brigden

27. **The Prairie** 1929
oil on canvas, 28.5 × 33.5cm
Collection of the Winnipeg Art Gallery
Bequest from the Estate of Arnold O. Brigden

28. **Poplar Woods** 1929
oil on canvas, 71.6 × 91.8cm
Collection of the Winnipeg Art Gallery
Purchased in memory of Mr and
Mrs Arnold O. Brigden

29. **Summer** 1931
oil on canvas, 34.5 × 42.5cm
Hart House Permanent Collection
University of Toronto, Canada

30. Landscape c.1931
oil on canvas, 29.3 × 34.6cm
Collection of the Winnipeg Art Gallery
Donation from the Douglas Duncan Estate

31. Broken Tree in Landscape 1931
oil on canvas, 35.5 × 42.8cm
Collection of the Winnipeg Art Gallery
Gift of The Women's Committee

32. The Pool 1934
oil on board, 36.2 × 43.7cm
National Gallery of Canada, Ottawa

33. Large Trees on the Riverbank (undated)
oil on canvas, 40.6 × 50.8cm
Agnes Etherington Art Centre
Queen's University, Kingston
Gift from the Douglas M. Duncan
Collection, 1970

Marc-Aurèle Fortin (1888-1970)

Fortin grew up in the Montreal suburb of Sainte-Rose. He studied in Montreal, and travelled for three years across the United States. From 1920 to the mid-1930s he produced an extraordinary series of works which depicted the area around Ste-Rose, when the suburban landscape is seen in an almost visionary intensity. He was involved in setting up the influential school L'Atelier in 1931 which did much to revive the art scene in Montreal, and paved the way for the emergence of a new modernism in the city.

34. Grandes Ormes à Sainte-Rose c.1926
oil on canvas, 126.4 × 97.2cm
Collection of Power Corporation of Canada

Clarence Gagnon (1881-1942)

Born in Montreal, he studied with William Brymner before attending the Académie Julian in Paris, like many of his generation. While he was a key figure in disseminating the Impressionist manner in Canada and figured in the Canadian Art Club exhibitions, he became increasingly attached to the Quebec 'habitant' life, and in Canada is probably best known for his sensitive illustrations to the classic French-Canadian novels such as Louis Hemon's Maria Chapdelaine. It is in this light that his most famous work *Village dans les Laurentides* is best understood.

35. Automne, Baie St-Paul 1909
oil on canvas, 73 × 91cm
The Montreal Museum of Fine Arts Collection
Donation of the Estate of J. A. Deséve

36. In the Laurentians, Winter 1910
oil on canvas, 59 × 79.4cm
National Gallery of Canada, Ottawa

37. Winter, Baie St-Paul 1910
oil on canvas, 72.9 × 91.9cm
Collection of Power Corporation of Canada

38. Les Laurentides L'Hiver c.1920
oil on canvas, 74.4 × 94cm
The Montreal Museum of Fine Arts Collection
Gift from A. Sidney Dawes Collection

39. Village in the Laurentians 1924
oil on canvas, 87 × 129.5cm
National Gallery of Canada, Ottawa

Lawren Harris (1885-1970)

Born into one of Canada's leading families, Harris went to study art in Berlin and Munich after leaving the University of Toronto. Returning in 1910, he was at the centre of artistic life in Toronto. Many of his circle, of artist friends and others involved in politics, business and other fields, created the agenda of anglophobe nationalism before the war. He suffered a serious breakdown during the First World War, in response to which the spiritual elements in his art and life strengthened, leading to his formal involvement in the Theosophical Society. After the success of the Group of Seven in the 1920s he left Toronto in 1934, to live in the United States. His landscape paintings (whose spiritual severity had intensified in parallel to Harris's search for a true Canadian subject, culminating in stark images of the Rocky Mountains and the Arctic) ended at this time. For the rest of his life Harris made abstract art, returning to settle in Vancouver and resuming an active role in artists organizations for the last two decades of his life.

40. The Gas Works 1911-12
oil on canvas, 58.6 × 56.4cm
Collection Art Gallery of Ontario, Toronto
Gift from the McLean Foundation, 1959

41. **Canyon V. Algoma Sketch XCVI** c.1920
oil on board, 27 × 34.8cm
The Edmonton Art Gallery Collection
Gift of Dr Max Stern, 1981

42. **Clouds, Lake Superior** 1923
oil on canvas, 101.6 × 127cm
Collection of the Winnipeg Art Gallery
Gift of Mr John A. MacAulay, Q.C.

43. **Autumn, Algoma** 1920
oil on canvas, 96.2 × 110.8cm
Victoria University
(in the University of Toronto), Canada

44. **Lake McArthur, Rocky Mountains** (undated)
oil on plywood, 30 × 38.1cm
Collection of the Winnipeg Art Gallery

45. **Lake Superior Sketch LI** (undated)
oil on board, 30.5 × 38.1cm
Art Gallery of Windsor Collection
Gift from the Douglas M. Duncan
Collection, 1970

46. **First Snow, North Shore, Lake Superior**
oil on canvas, 123 × 153.3cm
Vancouver Art Gallery
Founders Fund

Alexander Young (A. Y.) Jackson (1869-1952)

Originally from Montreal, Jackson's Paris education gave him a certain status when he first met the Toronto artists who were later to join him in becoming the Group of Seven. His awareness and facility generated some of the early masterpieces of the nationalist landscape genre, and his work for the Canadian War Records is outstanding. In the 1920s he was prominent in public debate, putting the Group of Seven case, and he travelled across Canada in his effort to broaden the depiction of the country. Later in his career he settled on the Quebec countryside around Charlevoix County and the rolling Alberta prairies as his two characteristic subjects. He was active in establishing the Canadian Group of Painters as a successor body to the Group of Seven. His memoir *A Painters Country* gives many insights – witting or not – into the issues surrounding the Canadian landscape painters of his generation.

47. **Night, Georgian Bay** 1913
oil on canvas, 53.3 × 64.7cm
National Gallery of Canada, Ottawa

48. **Terre Sauvage** 1913
oil on canvas, 127 × 152.4cm
National Gallery of Canada, Ottawa

49. **The Red Maple** 1914
oil on panel, 21.6 × 26.9cm
McMichael Canadian Art Collection
Gift of Mrs S. Walter Stewart

50. **Making the Grade, Montreal** 1915
oil on panel, 36.6 × 41.7 × 3.6cm (frame size)
Vancouver Art Gallery
Gift of Dr and Mrs Lawren Harris

51. **Springtime in Picardy** 1919
oil on canvas, 65.1 × 77.5cm
Collection Art Gallery of Ontario, Toronto
Gift from the Albert H. Robson
Memorial Subscription Fund, 1940

52. **Entrance to Halifax Harbour** 1919
oil on canvas, 64.8 × 80.6cm
The Trustees of the Tate Gallery, London

53. **First Snow, Algoma** 1919-20
oil on canvas, 107.1 × 127.7cm
McMichael Canadian Art Collection
In Memory of Gertrude Wells Hilborn

54. **Lake Cognaschene** 1920
oil on canvas, 50.8 × 61cm
Art Gallery of Windsor Collection
Gift of Edmond G. and Gloria Odette, 1976

55. **Lake Superior Country** 1924
oil on canvas, 117 × 148cm
McMichael Canadian Art Collection
Gift of Mr S. Walter Stewart

56. **Rocher de Boule** 1926
oil on panel, 21.6 × 26.7cm
The Edmonton Art Gallery Collection
Gift of the Artist, 1940

57. **Winter, Charlevoix County** c.1933
oil on canvas, 63.5 × 81.3cm
Collection Art Gallery of Ontario, Toronto

Charles W. (C. W.) Jefferys (1869-1952)

Originally from Kent, Jefferys's family moved first to Philadelphia before settling in Ontario. Jefferys trained as a lithographer, and worked in commercial art in Toronto and in the United States before deciding upon pursuing his career in Canada. On his return to Toronto in 1901 he joined the Toronto Art Students' League, and through it and through a variety of his own means, writing, illustration, and painting, expressed the view that Canadian art needed to depict Canadian subjects for the Canadian public. His series of prairie paintings are his masterpieces, despite his interest in depicting the Ontario landscape. He is well known to Canadians through his illustrations of Canadian history, used in text books and popular in reproduction.

58. **Western Sunlight, Last Mountain Lake** 1911
oil on canvas, 35¾ × 57¾"
National Gallery of Canada, Ottawa

59. **Storm on The Prairies (or Allegro Maestoso)** 1911
oil on canvas, 91.4 × 147.3cm
Ms Margaret W. Stacey

60. **A Prairie Sunset** 1915
oil on canvas, 71.6 × 124cm
Collection Art Gallery of Ontario, Toronto
Gift of Mrs K. W. Helm,
daughter of C. W. Jefferys,
Kneeland, California, 1980

Frank Johnston (1888-1949)

Johnston is an enigmatic figure. One of the original Group of Seven, he emerged from a Toronto education and a background in commercial art. He produced some of the most distinctive images in the Group's early exhibitions, yet his work became formularistic and decorative. After he left Toronto to be Principal of Winnipeg School of Art, 1920-24, he became distant from the Group, and by the time of his return to Toronto in the later 1920s became more hostile, eventually being one of the signatories to the petition raised against the National Gallery of Canada in 1932 as a protest by the Royal Canadian Academy.

61. **Edge of the Forest** 1919
oil and tempera on board, 52 × 62cm
Collection of the Winnipeg Art Gallery

62. **Fire Swept, Algoma** 1920
oil on canvas, 50¼ × 66"
National Gallery of Canada, Ottawa

Arthur Lismer (1885-1969)

Lismer was born and educated in Sheffield, and emigrated to Toronto in 1911. He soon moved to work at Grip Engraving when he met the nascent Group artists. From 1916-19 he taught in Halifax, Nova Scotia, but returned to Toronto, and was one of the original Group of Seven. His affable pragmatism meant he was well suited to an organizational role, while his straightforward commitment and outgoing manner made him a natural teacher and lecturer. He promoted the nationalism and modernism espoused by the Group in speaking tours, assisted in exhibition organization, and made notable achievements in setting up educational facilities, particularly the children's programme at the Art Gallery of Ontario. He was frustrated in his attempt to establish a national art education programme, but spent the last two decades of his working life with the Montreal Museum of Fine Arts.

63. **Sombre Isle of Pic** 1927
oil on canvas, 86.3 × 109.2cm
Collection of the Winnipeg Art Gallery
Gift of Mrs R. A. Purves

John Lyman (1886-1967)

Lyman's wealthy background in Montreal enabled him to study in Paris and travel in Europe through much of his early life. He knew many leading European figures, including Matthew Smith, as well as maintaining close links with J. W. Morrice. He returned to Montreal in 1931, when he began to write regularly as well as painting. As a critic he took an important stance, articulating the view that modernism and Canadian painting need not be solely in the terms set out by the Group of Seven and their circle.

64. **Westmount in Winter** 1912
oil on canvas, 40.8 × 32.4cm
National Gallery of Canada, Ottawa

James E. H. (J. E. H.) MacDonald (1873-1932)

Born in Durham, MacDonald's family moved to Hamilton, Ontario, when he was fourteen. He studied in Toronto and worked in commercial art, joining Grip Engraving in 1907. The oldest of the original Group of Seven, he was a quiet moving force, often leading in key early interests. In 1911 he began teaching at the Ontario College of Art, retaining a genuine interest in the importance of good graphic design. As with Lismer, it has been asserted that MacDonald's painting took second place to his teaching and other commitments; equally like Lismer, he produced some of the most memorable of Canadian paintings. His death in 1932 denotes the end of the Group of Seven 'era'.

65. **Trucks and Traffic** 1912
oil on canvas, 71.1 × 101.6cm
Collection Art Gallery of Ontario, Toronto
Gift of Walter C. Laidlaw, 1937

66. **March Evening, Northland** 1914
oil on canvas, 29½ × 39¾″
National Gallery of Canada, Ottawa

67. **Leaves in the Brook** c.1918
oil on pressed board (called panel), 23.1 × 26.6cm
McMichael Canadian Art Collection
Gift of Mr A. Y. Jackson

68. **Leaves in the Brook** 1919
oil on canvas, 52.7 × 65cm
McMichael Canadian Art Collection
Gift of Dr Arnold C. Mason

69. **October Shower Gleam** 1922
oil on canvas, 122.5 × 137cm
Hart House Permanent Collection
University of Toronto

70. **Rain in the Mountains** 1924-25
oil on panel, 123.5 × 153.4cm
Art Gallery of Hamilton
Bequest of H. L. Rinn, 1955

71. **Lake Oesa** 1929
oil on panel, 21.5 × 26.7cm
Art Gallery of Hamilton
Gallery purchase, 1952

72. **Leafless Woods, Algoma**
oil on panel, 20.8 × 25.8cm (sight)
Art Gallery of Hamilton
Gallery purchase, 1952

David Milne (1882-1953)

Milne grew up in Ontario, in a Scottish Presbyterian family. After studying in New York he stayed there and was involved with the current modernist art, exhibiting in the Armory Show in 1913. He took part in the Canadian War Records, and after the war sought ways of resolving his commitment to modernism with his personal attachment to a simple rural life, living in the Appalachian Mountains. He moved to Canada in 1928, settling in rural Ontario, in part to reconcile himself to the country of his birth. After the Second World War his sensitive, thoughtful painting took on strange dreamlike subjects, so that by the end of his life he had produced an extraordinarily rich body of work.

73. **Doorway of the Painting House** 1921
watercolour, over graphite on wove paper, 40.9 × 40.9cm
National Gallery of Canada, Ottawa

74. **Burnt Tree** 1923
watercolour, over graphite on wove paper, 38.6 × 55.9cm
National Gallery of Canada, Ottawa

75. **Reflected Pattern** c.1923
watercolour, over graphite on wove paper, 37.9 × 49.6cm
National Gallery of Canada, Ottawa

76. **Carnival, Dominion Square, Montreal** c.1924
oil on canvas, 40.6 × 50.8cm
Art Gallery of Windsor Collection
Gift of the Women's Committee, 1957

77. **Hillside Reflections** 1927
oil on canvas, 30.7 × 41cm (sight)
Art Gallery of Hamilton
Bequest of Mrs J. P. Barwick, 1985

78. **The Ski Jump** 1927
oil on canvas, 40.6 × 56.2cm
The Edmonton Art Gallery Collection
Gift of The Ernest E. Poole Foundation, 1975

79. **Untitled** c.1930
oil on canvas, 50.9 × 61cm
Collection of the Winnipeg Art Gallery
Gift of the Women's Committee

80. **Palgrave** 1931
oil on canvas, 45.7 × 61cm
Collection Art Gallery of Ontario, Toronto
Gift from the J. S. McLean Collection, 1969

81. **Farm in the Hills, Palgrave** c.1931
oil on canvas, 30.5 × 40.6cm
Hart House Permanent Collection
University of Toronto

82. **Ollie Matson's House in Snow** c.1932
oil on canvas, 50.8 × 61cm
National Gallery of Canada, Ottawa

83. **Splendour Touches Hiram's Farm** c.1932
oil on canvas, 51.4 × 61.6cm
National Gallery of Canada, Ottawa

84. **House and Clouds** c.1930-32
oil on canvas, 51.3 × 61.3cm
Collection of the Art Gallery of Nova Scotia

85. **Spring on Hiram's Farm** 1932
oil on canvas, 51.4 × 61.3cm
Collection of the Winnipeg Art Gallery
Bequest from the Douglas Duncan Estate

86. **Bright River** 1933
oil on canvas, 46 × 56.2cm
McMichael Canadian Art Collection
Gift of Mr Hart Massey

87. **Maple Leaves** 1937
oil on canvas, 46.2 × 56.2cm
National Gallery of Canada, Ottawa

88. **Summer Evening** 1937
oil on canvas, 31.1 × 36.2cm
Agnes Etherington Art Centre, Queen's University, Kingston
Gift from the Douglas M. Duncan Collection, 1970

89. **Winter Clouds** 1937
oil on canvas, 47 × 63cm
Hart House Permanent Collection
University of Toronto

90. **The Cross Chute** 1938
watercolour, over graphite on wove paper, 37 × 53.2cm
National Gallery of Canada, Ottawa
Gift from the Douglas M. Duncan Collection, 1970

91. **Blue Sky, Palgrave** (second version)
print, 17.5 × 22.5cm
National Gallery of Canada, Ottawa

5 prints from the group *Outlet of the Pond*, 1930
each image 17.6 × 22.6cm.

2 prints from the group *Barns*, 1931
each image 17.6 × 22.6cm

James Wilson Morrice (1865-1924)

Although he is one of Canada's greatest and best known artists, Morrice rarely spent substantial periods of time in the country once he had left his Montreal home to study in Paris in 1889. He exhibited with the Canadian Art Club, but despaired of ever trying to sell or receive worthwhile anticism in his home country. His Canadian subjects are often winter scenes since they were made during Christmas visits to his family. Many of his works are of Mediterranean and Caribbean scenes, where his ability to prompt a vivid sense of place within superb, aesthetic constructions is seen to the full.

92. **The Ferry, Quebec** c.1906
oil on canvas, 62 × 81.7cm
National Gallery of Canada, Ottawa

93. **Éffet de Neige, Le Traineau** 1906
oil on canvas, 60 × 50.5cm
Lyon, Musée des Beaux-Arts

94. **Étude pour' Pont de Glace sur la Rivière St-Charles'** c.1908
oil on wood, 17.7 × 25.2cm
The Montreal Museum of Fine Arts Collection
Gift of the Executors, Estate J. W. Morrice

95. **Pont de Glace sur la Rivière St-Charles'** 1908
oil on canvas, 60 × 80.6cm
The Montreal Museum of Fine Arts Collection
Gift of the Executors, Estate J. W. Morrice

96. **House in Santiago** c.1915
oil on canvas, 54 × 64.8cm
The Trustees of the Tate Gallery, London

97. **Quebec Farmhouse** c.1921
oil on canvas, 81.2 × 60.3cm
The Montreal Museum of Fine Arts Collection
William J. Morrice Bequest

98. **Ste-Anne-de-Beaupré** 1897
oil on canvas, 44.4 × 64.3cm
The Montreal Museum of Fine Arts Collection
Gift from William J. Morrice

W. Goodridge Roberts (1904-74)

Roberts arrived in Montreal in his twenties, having travelled widely with his family: his father was the novelist, Theodore Goodridge Roberts, his cousin, Bliss Carman. He admired Morrice, and after Lyman returned to Montreal, Roberts found encouragement, and practical support through the newly formed school L'Atelier. His work is a demonstration of Lyman's belief that modern landscape painting is part of an aesthetic and philosophical project, not necessarily a nationalist one, and his figure painting has been acclaimed alongside his (often closely related) landscapes.

99. **Lake Bernard** 1934
oil on board, 50.8 × 75.5cm
The Edmonton Art Gallery Collection
Purchased in 1979 with funds donated
by the Women's Society
of the Edmonton Art Gallery
in Memory of Andrew Sidlo

100. **Laurentian Landscape** 1939
watercolour on paper, 52 × 62.9cm
The Montreal Museum of Fine Arts Collection
purchase, Gilman Cheney Bequest

Sarah Robertson (1891-1948)

Robertson was one of a number of women artists who were associated with the Beaver Hall Group, a Montreal group which echoed some of the artistic goals of the Group of Seven. Robertson studied with Brymner, before coming under the influence of the younger artists, and her work mixes witty observation with modernist painting.

101. **Storm, Como** (undated)
oil on canvas, 63.5 × 71.5cm
Agnes Etherington Art Centre, Queen's University, Kingston
Purchased with the assistance of the chancellor Richardson
Fund and the Province of Ontario through Wintario

Albert H. Robinson (1881-1956)

Robinson was born in Hamilton, Ontario, and studied in Paris. A friend of A. Y. Jackson, Robinson was included in the first Group of Seven exhibition in 1920, as an invited artist, but he was distanced from the Group's ideological and spiritual core. Like Jackson he often depicted the gentle countryside of Charlevoix County in Quebec.

102. **Village on the Gulf** 1924
oil on canvas, 66 × 83.8cm
Collection Art Gallery of Ontario, Toronto
Gift from the Fund of the T. Eaton Co. Ltd.,
for Canadian works of Art, 1950

103. **Falling Snow, Les Éboulements** 1926
oil on canvas, 69.5 × 84.4cm
Art Gallery of Hamilton
Gallery purchase, 1948

Carl Shaefer (1903)

Born in Hanover, Ontario, Shaefer studied at Ontario College of Art, and lived in Toronto. After experimenting with landscape and mural painting in the shadow of his tutors and mentors Lismer, MacDonald and their immediate circle, during the Depression found a genuine difficulty in surviving as an artist. This forced him back to his family home, which he then depicted in a series of brilliant oils and watercolours. He is also known as the subject of Comfort's great image of the Depression *The Young Canadian*.

104. Storm over the Fields 1937
oil on canvas, 68.6 × 94.6cm
Collection Art Gallery of Ontario, Toronto
Gift from J. S. McLean Canadian Fund, 1954

Tom Thomson (1877-1917)

Thomson grew up in Owen Sound, Ontario, and the only time he left
Ontario was to work in Seattle as a commercial artist, 1901-5. He joined
Grip Engraving in 1908, and met MacDonald, then Lismer, Varley,
Carmichael and Johnston. The other artists admired his innate feeling for
the Ontario landscape, whilst he infused his own skill as a designer with a
high-key painting technique adapted from experiments with late- and
post-Impressionist application. He died in 1917, drowning whilst
canoeing alone in Algonquin Park, since then he has been mythologized,
often as the archetypal Canadian man.

105. Parry Sound Harbour 1914
oil on panel, 21.6 × 26.6cm
National Gallery of Canada, Ottawa

106. Afternoon, Algonquin Park 1914
oil on canvas, 63.2 × 81.1cm
McMichael Canadian Art Collection
In Memory of Norman and Evelyn McMichael

107. Silver Birches c.1914
oil on panel, 40.9 × 56cm
McMichael Canadian Art Collection
Gift of Col. R. S. McLaughlin

**108. Winter, Study for Afternoon,
Algonquin Park** c.1914
oil on panel, 21.7 × 26.7cm
McMichael Canadian Art Collection
Gift of Mr and Mrs R. G. Mastin

109. Log Jam c.1915
oil on panel, 12.6 × 17.5cm
McMichael Canadian Art Collection
Anonymous Donor

110. Fraser's Lodge (Mowat Lodge) 1915
oil on panel, 21.9 × 27cm
The Edmonton Art Gallery Collection
Gift of Mrs Gertrude Poole, 1977

111. Algonquin Waterfall c.1916
oil on panel, 21.2 × 26.7cm
McMichael Canadian Art Collection
Anonymous Donor

112. Snow in the Woods c.1916
oil on panel, 21.9 × 27cm
McMichael Canadian Art Collection
Purchased with funds donated
by Mr R. A. Laidlaw

113. The West Wind 1917
oil on canvas, 120.7 × 137.2cm
Collection Art Gallery of Ontario, Toronto
Gift of the Canadian Club of Toronto, 1926

114. Autumn Foliage
oil on panel, 21.6 × 26.7cm
Collection Art Gallery of Ontario, Toronto
Gift from the Reuben and
Kate Leonard Canadian Fund, 1927

115. Autumn, Algonquin Park (undated)
oil on panel, 21.3 × 26.4cm
Agnes Etherington Art Centre,
Queen's University, Kingston
Presented by Queen's Art Foundation, 1941

116. Petawawa Gorges (undated)
oil on panel, 20.5 × 25.3cm
McMichael Canadian Art Collection
Purchased with funds donated
by Major F. A. Tilston, V.C.

117. A Rapid
oil on panel, 21.6 × 26.7cm
Collection Art Gallery of Ontario, Toronto
Gift of Mr and Mrs Lawren S. Harris,
Toronto, 1927

Frederick H. Varley (1881-1969)

Varley, the son of a commercial artist, grew up in Sheffield and worked in London before following Lismer to Toronto in 1912. While he shared the enthusiasm for landscape, during work for the Canadian War Records he produced some of his greatest works, and in the first Group of Seven exhibition he showed portraits as well as the famous landscape work. For the rest of his errant life he worked unevenly, producing phases of fine landscape work in British Columbia in the late 1920s and mid-1930s, and some remarkable images of the Arctic, together with memorable portraits. However, he often found it difficult to maintain stable circumstances in which to work, leading him to be characterized as the romantic wanderer of the Group of Seven.

118. **The Cloud Red Mountain** 1928
oil on canvas, 87 × 102.2cm
Art Gallery of Ontario

Biographies written by Michael Tooby.

PHOTOGRAPHIC ACKNOWLEDGEMENTS

Barbican Art Gallery would like to thank all lenders for their co-operation in the production of the photographs and for kindly allowing us to reproduce their works. We would further like to acknowledge and thank the photographers listed below for their efforts on our behalf.

Multi Media Techniques, Hamilton, Ontario
TDF Artists, Toronto
T.E. Moore, Toronto; courtesy, Robert Stacey
Winnipeg Art Gallery; Ernest Mayer

LIST OF LENDERS

Agnes Etherington Art Centre, Queens University, Kingston
The Edmonton Art Gallery Collection
Art Gallery of Hamilton
Hart House, Permanent Collection, University of Toronto
Lyon Musée des Beaux-Arts
McMichael Canadian Art Collection
Musée des Beaux-Arts de Montréal
National Gallery of Canada, Ottawa
Collection of the Art Gallery of Nova Scotia
Collection of the Art Gallery of Ontario, Toronto
Collection of the Power Corporation of Canada
Ms Margaret W. Stacey
The Trustees of the Tate Gallery, London
University College, University of Toronto
Vancouver Art Gallery
Victoria University, in the University of Toronto
Art Gallery of Windsor Collection
Winnipeg Art Gallery

Copyright © 1991 Barbican Art Gallery
Corporation of the City of London
Level 8, Barbican Centre
London EC2Y 8DS

First published in 1991
by Lund Humphries Publishers Ltd
16 Pembridge Road, London W11
in association with
Barbican Art Gallery, London

British Library Cataloguing in Publication Data
The True North: Canadian Landscape Painting.
1. Paintings 2. Canada
I. Tooby, Michael II. Barbican Art Gallery
759.11

ISBN 0-85331-586-8

Distributed in Canada by
Raincoast Book Distribution Ltd
112 East 3rd Avenue,
Vancouver, British Columbia,
Canada V5T 1C8

Exhibition selected by Michael Tooby and organised by Brigitte Lardinois, with assistance from Carol Brown and Donna Loveday, Barbican Art Gallery
The exhibition is sponsored by Air Canada and The Daily Telegraph, and is supported by the Culture and Sports Division of the Department of External Affairs and International Trade, Government of Canada; the Canada Council for the Arts; the Canadian High Commisssion, London and Visiting Arts, London.

This is the catalogue of the exhibition
THE TRUE NORTH: CANADIAN LANDSCAPE PAINTING 1896-1939
held at Barbican Art Gallery, London
from 19 April to 16 June 1991

Edited by Charlotte Burri and Michael Tooby,
Brigitte Lardinois and Donna Loveday
Designed by Cara Gallardo and Richard Smith, Area
Typeset by Ampersand Bournemouth Creative Ltd.
Made and printed in Great Britain
by BAS Printers Ltd, Over Wallop
Stockbridge, Hampshire